LOST
COVENTRY

DAVID MCGRORY

AMBERLEY

Acknowledgements

Thanks to those who have supplied images and information: Rob Orland, John Ashby, Paul Maddocks, Simon Shaw, Jane Gibson, Mrs E. W. Harris, Fred Jennings. Images are welcome to be used on Facebook pages with due acknowledgement.

First published 2022

Amberley Publishing
The Hill, Stroud
Gloucestershire, GL5 4EP

www.amberley-books.com

British Library Cataloguing in Publication Data.

A catalogue record for this book is available from the British Library.

ISBN 978 1 3981 1033 5 (print)
ISBN 978 1 3981 1034 2 (ebook)

Origination by Amberley Publishing.
Printed in the UK.

Contents

Introduction 4

1 People 5

2 Buildings 14

3 Sport and Entertainment 36

4 Streets 47

5 Industry 65

6 Moments in Time 76

Introduction

Producing a book on 'lost Coventry' should be easy, but it wasn't because so much has been lost here. I started with over 600 images but had to cut them down to around 160 to suit the parameters of the book. It is based almost entirely on the last 120 years, so we see little of the city before the twentieth century. In the past the city was packed with timbered buildings – practically all now lost. In many ways Coventry itself is a lost city, afflicted not only by demolition but also bombing. Much of the city's destruction lay in the hands of those who should have cared for it, notably Coventry's own city council (or corporation as it was then); adding to this was Hitler's efficient Luftwaffe. Luckily, despite all this most of the non-domestic, large, historic buildings within the centre survived. In the past the council had plans to demolish most of these, including Drapers Hall, County Hall, Grammar School and Fords Hospital, but something or someone changed their plans. Coventry has lost huge swathes of the old city; its buildings, streets, courts, alleys and landmarks have been obliterated, making it easy to look at an old view and see little or nothing that has survived. Several hundred ancient buildings were destroyed after the war in the name of 'progress', and this occurs even in modern times as early nineteenth-century villas have been demolished for student blocks.

What makes old pictures important is that the past survives within them – even scenes of people can show us parts of a lost landscape. Having studied scenes of the city for many years, however, I know there are many parts that were never photographed. We have reached a period where fewer people remember what the old city looked like. Building work has not stopped since the Second World War, so even those familiar with mid-twentieth-century Coventry are losing track with its many changes and proposed developments. The modifications in the city are now getting so constant that even 'then and now' books published in recent times are outdated within a year – in fact, the precinct has changed since I started preparing this book.

So much in the past becomes lost: aspects of the city, individuals, industries, buildings, sports and entertainment. Time moves onwards and all passes by.

I

People

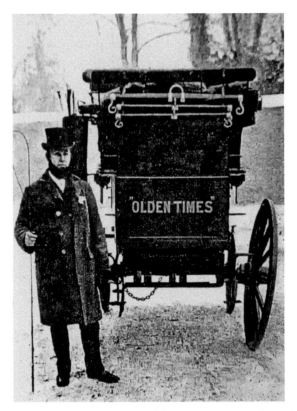

Walter Daniel Claridge in 1898 with his coach, *Olden Times*. Dan was a Victorian and he dressed like one, with a frock coat, top hat and whiskers. He kept the Craven Arms, High Street, for over forty years, running coaches between Coventry, London and Birmingham. He stabled forty horses and was a skilled driver of the stagecoach. He tried reviving coaching in 1874, driving his coach to London in under twelve hours. He also ran coaches to Birmingham. Dan drove the last regular Coventry to London coach, the *Emperor Alexander*, on 12 August 1874. He ran the *Emperor* again under its new name, *Olden Times*, from 1892 to 1899 to London, Dunchurch, Leamington, Coleshill and Monk's Kirby. He later moved to the Craven Arms in Binley. In 1915 he said, 'If I go up to town now I hardly see a soul that I know, whereas fifty years ago, I knew practically everyone I met.' When he died in 1923 Dan was described as being a 'veritable landmark in the historic city'.

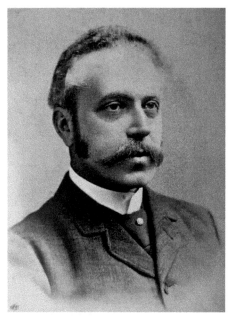

While his uncle James Starley was the father of the cycle, John Kemp Starley brought it to the masses. In eight years the bone-shaker of 1868 was transformed by James into the Ordinary, which had two different-sized wheels. The introduction of J. K.'s Rover cycle in 1885 marked the birth of new era, making cycling available to all. It had every feature found in the modern cycle: equal-sized wheels, chain drive, diamond frame, sloping forks, adjustable handle bar and saddle. Manufacturers copied it and for years all rear-driven cycles were called 'Rover Pattern' and later 'the safety cycle'. John Kemp lived to see the birth of the twentieth century, dying at Barrs Hill House in October 1901, aged forty-six. The national memorial that there were calls for sadly never materialised.

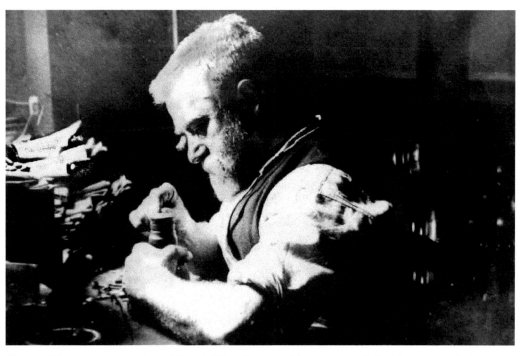

Thomas Chapman, watchmaker of No. 4 Priory Row, working on a watch by his cottage window around 1900. Thomas represents a lost trade, which was once one of the city's main industries. He died in March 1920, aged seventy-one, after serving for thirty-seven years as assistant and twenty years as sexton and clerk of Holy Trinity. He had an interest in history and his home was a treasure trove of items, including weapons. He was also interested in drama and acted, keeping his *Hamlet* skull in his cottage. As a Freemason, his funeral was attended by many fellow masons and was led by the Grand Master of the Warwickshire Lodge, Colonel William Wyley.

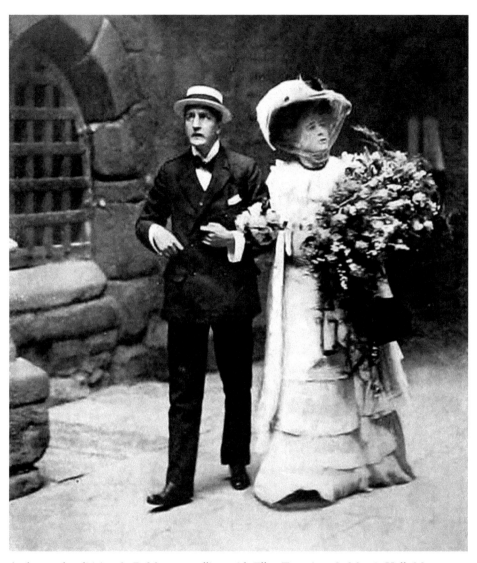

Author and politician A. E. Mason strolling with Ellen Terry into St Mary's Hall. Mason was Liberal MP for Coventry from 1906 to 1910 before writing finally overtook his interest in politics. *The Four Feathers* was Mason's most celebrated work, and *The Turnstile* (1912) was based on a fiery campaign in Coventry, assisted by J. M. Barrie, author of *Peter Pan*. Ellen Terry, the greatest female actor of her time, was born in Coventry on 27 February 1847 while her parents were touring. Her birthplace was conjecture for years and two opposing buildings in Market Street, Nos 5 and 26, claimed to be it. No. 26 pushed itself as a shrine to theatregoers, but No. 5 was her real birthplace – it was confirmed in 1893 by the nurse who brought her into the world. Despite this both houses bore plaques making their claim until they were destroyed on 14 November 1940. A commemorative stone and plaque in the Upper Precinct are now gone.

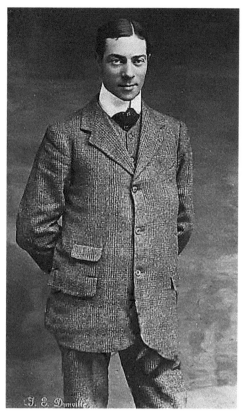

T. E. Dunville (Thomas Edward Wallen), one of the greatest music hall comedians, was born in Coventry in 1870. He trained as a clerk but left at seventeen and joined a travelling pantomime. In 1889 the manager of the Victoria, Bolton, let him do a turn. He was an instant hit, becoming king of the music hall for over thirty years. In March 1924 while playing the Grand Palace, Clapham, he unexpectedly went for a walk, leaving a note for his wife that read, 'God bless you and Tom [his son]. I feel I cannot bear it any longer. Good-bye. You are the best little woman in the world.' His wife said he felt he was being put under strain and worried he was ill, though doctors said he was fine; he also felt managers were turning against older entertainers. Throughout that week he had received ovations, but Gertie Litiana, on the same bill, said he was nervous and unjustifiably apprehensive of his reception by the public. 'He was hyper-sensitive about his work,' she said. 'He put on a new song, and felt very nervous about it. He thought it had not gone well, and he did not like it himself.' Thomas drowned himself in the Thames at Caversham Lock. His death was reported worldwide.

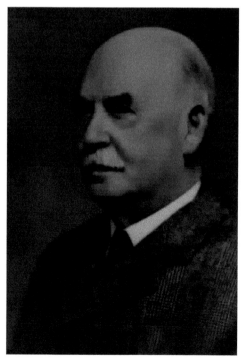

Colonel Sir William Fitzthomas Wyley, the 'Grand Old Man of Warwickshire', died at his home, the Charterhouse, on 11 August 1940, aged eighty-eight. Born at Stoke House in 1852, he joined the 2nd (later 7th) Battalion Royal Warwickshire Regiment in 1872 and became colonel commandant in 1898, holding the rank until his retirement in 1908. He led recruiting for the Boer War and the First World War, in which his only son was killed. Knighted in 1938 for services to Coventry and Warwickshire, he was deputy lieutenant for the county and high sheriff. He was twice mayor of Coventry, an alderman and served forty-one years on the council. He was Grand Master of the Warwickshire Freemasons and director of the Midland Bank and a chairman of Rover. A great benefactor, his greatest gift was his home, the Charterhouse, which he wanted to be a folk museum. After years of council misuse and threat of sale, it is now managed by the Historic Coventry Trust and recognised as a building of national importance.

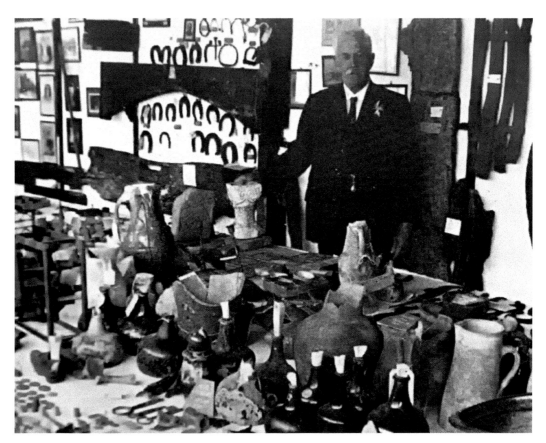

John Bailey Shelton, born in 1875, son of a Nottinghamshire farm labourer, came to Coventry in 1897 where he married and started his own cartage business. In 1926 he began unearthing medieval pottery and tiles while accessing the site of the Hare and Squirrel. Thereafter, he befriended the men on the building sites, who kept him informed and let him dig. In 1937 the mayor opened Shelton's 'Benedictine Museum'. On 14 November 1940 his home was wrecked by firebombs. The museum was damaged, but its contents were saved as he packed them into boxes, placed them in a narrow space between brick buildings behind his home and covered them with corrugated iron – they survived untouched. During this raid he rescued his five horses from their burning stables, winning the RSPCA's silver medal. His home was practically destroyed, his books and papers lost, so John set up a caravan on the site and rebuilt his museum in the remains of his home. In 1955, now in Priory Street, he donated his collection to the planned new museum, forming the core of Coventry's archaeological collection. He died aged eighty after being hit by a motorcycle. One of nature's gentlemen, he tended the garden at Fords Hospital and was a loved guardian of St Mary's Hall, for which he was made city chamberlain. He was also awarded the MBE.

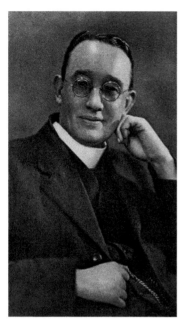

George William Clitheroe, the man who saved Holy Trinity, was a canon of Coventry Cathedral and vicar of Holy Trinity from 1931 to 1964. During a raid in October 1940, he fought an incendiary fire on the roof until the fire service arrived. He spent the night of 14/15 November with his assistants dealing with incendiaries on the roof as the city burned around them – he likened it to Dante's *Inferno*! After hearing that the bishop of Coventry had previously accepted the possible loss of the cathedral, he wrote: 'I was never prepared to face the possibility of losing Trinity while I could save it.' Adding, 'What my colleagues and I would have liked would have been the possession of a gun on the roof in order that we could have been offensive as well as defensive.' He hung a huge banner across the frontage stating, 'It all depends on us and we depend on God.' The bishop of Coventry, Cuthbert Bardsley, said of him after his death, 'He fought against everything he considered to be dishonest, unworthy and detrimental to the well-being of the nation. He was a redoubtable friend and an indomitable foe … Through his energetic spirit he saved Holy Trinity Church from destruction during air raids on the city.'

Sir Alfred Herbert, centre left, at the reopening of Fords Hospital in 1953. The 'father' of the British machine tool industry founded a worldwide industrial enterprise bearing his name. Son of a Leicestershire farmer, he planned to be a parson, but changed his mind after visiting an old school friend in a Leicester engineering factory – Jessop's. He was apprenticed there and later in 1887 became manager of Coles & Matthews, Butts, Coventry. A year later he owned it. In 1894 he formed Alfred Herbert Ltd. Alfred got his knighthood in 1917 for his war work with the Ministry of Munitions, in which he was Deputy Director-General. He gave gifts to Coventry, including Lady Herbert's Garden and its almshouses, which he designed as a memorial to his second wife, Florence. His greatest gifts were £200,000 to build the Herbert and a huge sum towards the new cathedral, despite favouring rebuilding the old. He actively ran his company until he died on 26 May 1957 aged ninety years. Sir Alfred was remembered for his friendliness and generosity. He would often visit the shop floors just to chat to 'my men' as he called them.

A composite photograph taken on 16 May 1952 by photographer Arthur Cooper when Harry Weston was mayor and master of the Freeman's Guild. Born in Clarendon Street, Earlsdon, in 1896, in 1928 he founded Modern Machine Tools, producing water pumps, lathes and other machinery. Harry made an extensive contribution to Coventry civic and public life, becoming a Conservative councillor in 1936. He was an alderman from 1955 to 1974 and was elected mayor in 1951. He was awarded the MBE in 1974 and died in 1989, aged ninety-two. Remembered with affection, Harry did much for the people of Coventry.

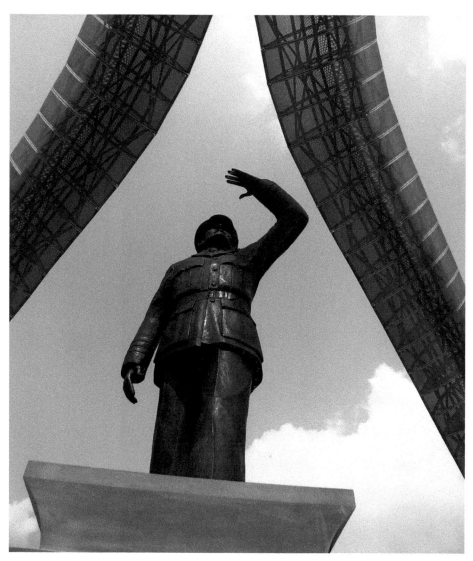

Statue of Sir Frank Whittle, the father of the jet engine, in Millennium Place. Sir Frank invented the turbo-jet engine. It was in his first patent and was published in January 1930 (predating later claims) when he was twenty-two years old. His invention revolutionised civil and military air transport the world over. Born in 1907 at No. 72 Newcombe Road, Earlsdon, while kite flying on Hearsall Common in 1916 he witnessed an aeroplane take off, blowing his hat into a bush and beginning his fascination with flight. Apprenticed into the RAF in 1923, he became a pilot officer in 1928. By October 1929, his mind turned to jet propulsion using a gas turbine enclosed in a fuselage to create fast air flow, propelling aircraft at high altitude. The Air Ministry turned it down, so he patented it himself. In 1935, he secured backing and Power Jets Ltd began constructing a test engine. Whittle needed a complete rebuild, and negotiations with the Air Ministry secured it in 1940. The engine had its first flight on 15 May 1941 in a Gloster E.28/39. In October a Power Jets team and engine flew to Washington and their XP-59A Airacomet was flying in October 1942. The British Gloster Meteor jet became operational in 1944. Whittle retired from the RAF in 1948 an air commodore and was knighted the same year. He died in Canada on 9 August 1996.

Sir William Lyons, chairman and managing director of Jaguar Cars Ltd, founded the Swallow Sidecar and Coach Building Company in Blackpool when aged twenty. He was not a qualified engineer, but he had an eye for the line of a fine vehicle. In the early 1920s Lyons created bodies for Austin Seven cars, Austin Swallows, and in 1928 he and his partner moved from Blackpool to Coventry, to the Whitmore Park Estate. Here he ordered a supply of chassis and engines from the Standard Motor Company and put on them bodies of his own design made at his new factory. These were the beautiful SS cars. He produced a new car in 1936 called the SS Jaguar and a famous name was born. After the war the company dropped 'SS' because of its Nazi connections, calling it Jaguar Cars and moved to Browns Lane. Although Jaguar doesn't build in Coventry now, its world base is here. Sir William Lyons died at his home, Wappenbury Hall, on 8 February 1985.

2

Buildings

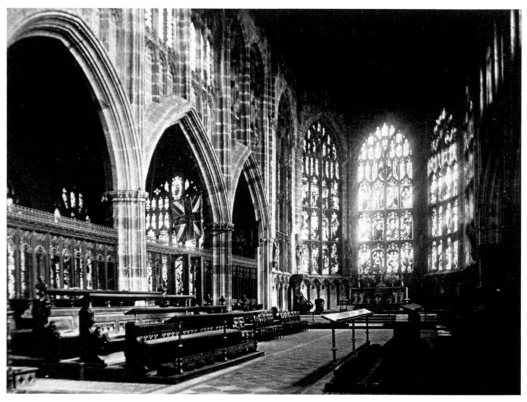

The chancel and apse of St Michael's (Old Cathedral) in 1900, seen here colourised. The apse has five windows and the three in the middle contained memorial glass to Queen Adelaide, widow of William IV. The central panel was a gift from Coventry's MP, Sir Edward Ellice. The other two panels, dating to 1853, were paid for by public subscription. The two side panels were filled with a collection of medieval glass, with much by the famed John Thornton.

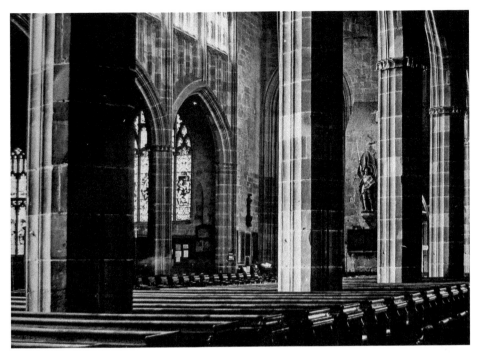

Looking across the nave and tower in the 1930s. Through the fluted Perpendicular columns on the right of the tower arch is an oak statue of St Michael. Beyond, on the left, is the stained-glass window by the south entrance, to the left of which is the window in the Dyers Chapel.

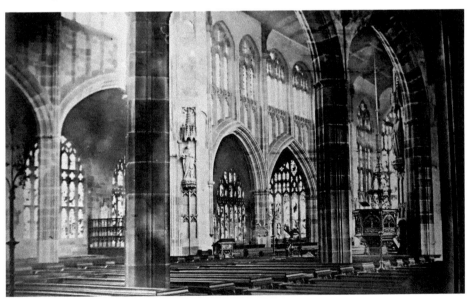

Looking across the nave through the column arches into the Lady Chapel and the Lawrence Chapel (left). On the right is Francis Skidmore's pulpit – the upper part being brass, the lower ironwork. At its base is engraved 'To the Glory of God and in loving memory of Ernest Edward their only son this pulpit was erected in the Church by Robert Arnold and Sarah Dalton, Easter Day 1869'. Dalton was a churchwarden, alderman and mayor of the city in 1874.

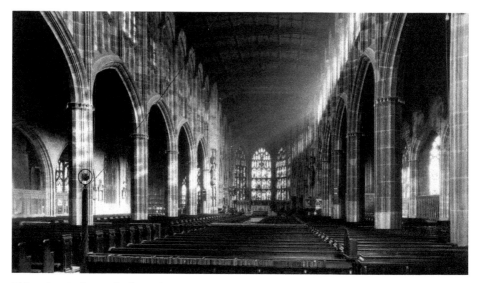

This colourised view looking down the nave and chancel taken in the 1920s is from about a quarter of the way down. The first church here in 1135, built by Ranulf, Earl of Chester, was given to the monks of Coventry Priory. In the early 1200s it was called Saint Michael in the Bailey as it stood within the bailey of the castle. In the thirteenth century it was replaced by a larger Early English church in the Decorated style. The tower and spire, declared a masterpiece by Sir Christopher Wren, is the third tallest in England, unique because unlike its rivals Salisbury and Norwich it is the highest in the land built from the ground, not from the centre of the church. Made a cathedral in 1918 on 14 November 1940, it was gutted by incendiaries.

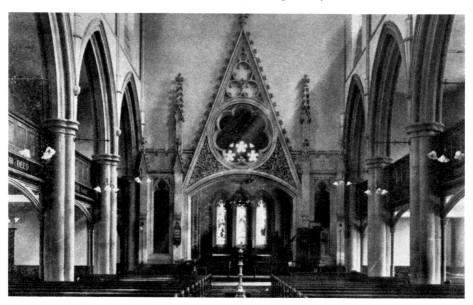

A colourised interior of Christ Church taken before its destruction in April 1941. The original church, called Greyfriar's, was destroyed in the Dissolution. This new church body was designed by Birmingham architects Rickman and Hutchinson and opened on 8 November 1832. The old sandstone tower was clad in Bath stone and formed the end of the church not the middle, due to other buildings encroaching on the original site.

A colourised St Nicholas' Church, Radford, in the 1920s. It was consecrated in 1874 and carried the name of the ancient church that stood off Sandy Lane. In the churchyard well-known names could once be found, such as the famous naturalist Revd John George Wood, who died on a visit; the England cricketer and friend of Grace, Andrew Ernest Stoddard, whose end was tragic; and Henry Sturmey of Sturmey-Archer gear fame. The church was flattened on the night of 14 November 1940. Its post-war replacement, a unique building, awaits demolition.

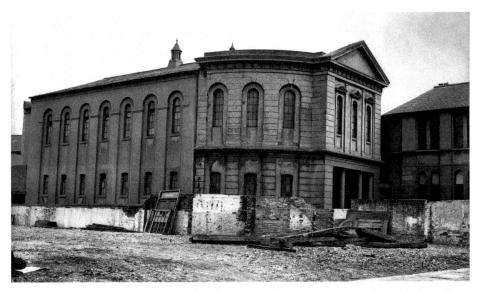

A colourised view of West Orchard Chapel in 1939. The congregation originated in Vicar Lane Chapel, but, dissatisfied with their minister, met in a room in Little Park Street. They then erected a chapel in West Orchard, which opened in 1777. This building replaced it in 1820. It held 1,200 people and had a schoolroom. A new hall and schoolrooms were added in 1936. Surprisingly, there were burials in a small, attached yard. Destroyed in the Blitz, it lies under West Orchard shopping centre.

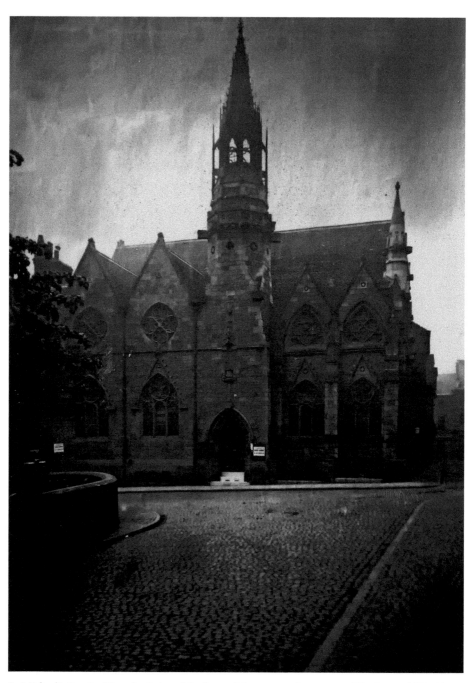

St Michael's Baptist Church, designed by James Murray, on the corner of Bayley and Hay Lane. Sir Joseph Paxton was delayed so missed the stone laying, but he attended the dinner. Built in eighteen months, it opened in 1858. Inside was a high rose window and oak and brass in the Arts and Crafts style. Just below the rose window was a stone pulpit so the vicar was level with the upper tiers and looked down into the main congregation. Gutted on 14 November 1940, its base and underground schoolroom became an emergency water tank for firefighters. The shell stood until the 1980s when a pub/restaurant was built here.

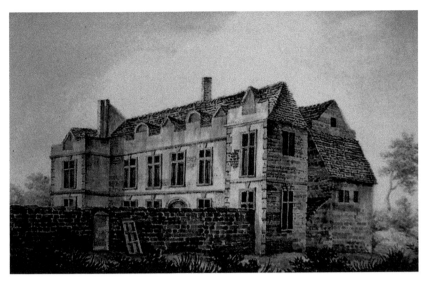

Foleshill Hall in Lythalls Lane dated from before the seventeenth century, and in 1840 was the farm of Mr Hawkins. From the 1870s the architect Thomas Tickner, designer of the Coventry War Memorial, lived here; it was his father's home previously. In Tickner's time it had a pillared entrance and on the front corners of the garden wall were square, stone summerhouses. It was converted into a public house in 1915 with 1¾ acres of land and was called the Foleshill Olde Hall Hotel. Its oak staircase dated to the early seventeenth century, though other parts were considerably older. This ancient building bears little resemblance to the brick, refaced version that was demolished in the 1980s.

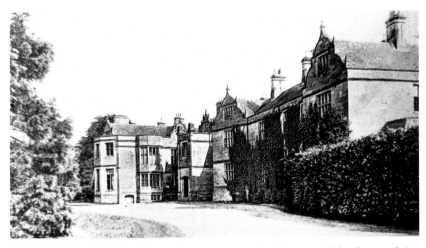

A colourised Whitley Abbey – who could believe such a building would be destroyed. Dugdale states in 1658, 'There only remains a manor house, with a chapel and a mill.' This may have borne the name Whitley Hall, been enlarged in the classical style in 1808 and thereafter called Whitley Abbey. A fire in 1874 almost destroyed the west end, but Edward Petre had it rebuilt and the grounds turned into a stunning area, especially the medieval quarry, which became a fern grotto with stone-carved avenues and steps. His wife and son lived there after his death and during the First World War it housed Belgian refugees. By 1924 it stood derelict, every window smashed, but its pool still attracted swans and swarmed with fish. The council acquired it and demolished it in 1953 to build Whitley Abbey School.

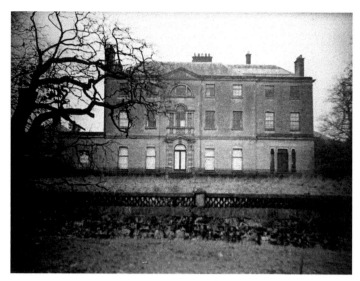

Stivichall Manor was held by the Gregorys since 1573. Arthur Gregory built this hall in 1755, removing the original hamlet and leaving only the church, Stivichall Grange and other buildings. The last of the Gregorys died in 1909 and it passed to his cousin Alexander Hood, who adopted the name Gregory-Hood. He sold part of the land to the corporation for the Memorial Park in 1922. He was succeeded by his son, Major Charles Gregory-Hood, who sold another part to Coventry Corporation and the remainder, including the hall, its park and Park Farm, to builder John Gray (who also acquired Coombe Abbey) in 1928. Gray demolished the hall in 1939/40 and the grounds and estate were built over between the 1930s and 1970s.

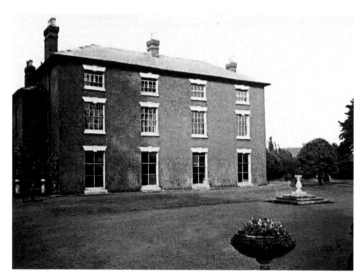

The original moated Walsgrave Hall stood near the river. The later hall, mentioned in 1559, stood on the site of Cloister Croft. In the eighteenth century it came to William Wale and in 1781 to William Brown – Wale's daughter's husband. It was he who rebuilt this twenty-two-roomed hall in 1823. The hall and 380 acres passed to John Brown-Izon in 1860 and remained in the family until 1901 when it was sold to oil magnate William Wakefield, who lived here until 1952. That year it was sold and converted into flats. It was then sold on in 1961 for £15,000 and demolished; part of the site was used for flats and part for Walsgrave Hospital.

Barrs Hill House, dating from the 1850s, belonged to John Bill, a Coventry and Warwick magistrate in 1863. In 1889 Bill's widow put it up for sale and, with 3½ acres, described as being set in excellent hunting country. In March 1896 it was acquired by John Kemp Starley of safety cycle fame, who enlarged and modernised it. Starley died in 1901 and it was up for sale again in 1903, described as having terraced walks with borders, ornamental trees, evergreen and flowering shrubs, elm and beech trees, a conservatory, glasshouses by a fruit and vegetable garden with paddock set in 4½ acres. The house had a spacious entrance hall with polished oak parquet floor, a handsome drawing room, dining room, a large library, a study, a breakfast room, kitchens, domestic offices and spacious, dry cellars. The first floor was reached by a handsome staircase carved in American walnut with lantern lighting, large landings and servant's staircase with ten bedrooms, dressing rooms and two bathrooms. Not meeting the price, it was withdrawn. In 1906 Mrs Starley sold it to the council for £5,500. It was turned into a girls' secondary school in June 1907, remaining as such until the 1970s when it became a mixed comprehensive. Starley's house was demolished for the school car park in 1982.

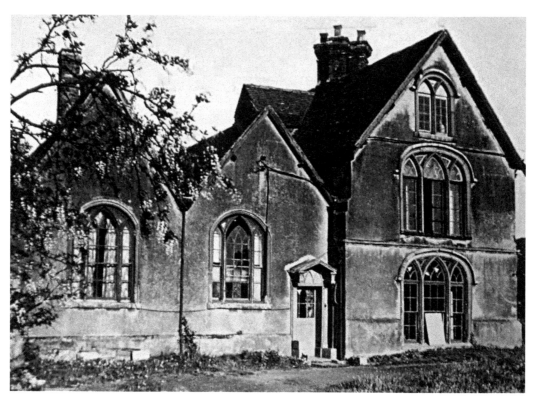

Willenhall Hall, or House, is said to be Georgian and stood off London Road, near the corner of St James's Lane, nearly opposite the Chace. In 1830 it was described as 'comprising Breakfast, Dining, Drawing, and Sitting Rooms, with seven Chambers also Cellarage, House keeper's Room, Butler's Pantry and appropriate domestic Out-offices, Coach Houses and Stabling; together with Pleasure Ground, Kitchen Garden (walled round), and upwards of Forty Acres of superior Pasture and Meadow Land ... commanding beautiful and extensive prospects of the surrounding Country'. In 1850 there was a sale of furniture, paintings and a phaeton carriage belonging to Mr Houghton, who was leaving. It was a farm in 1853 and by 1886 was the residence of Lieutenant-Colonel Battine, followed in 1907 by Edmund Lewis, manager of Coventry Motor Company. During the war it was wrecked by a bomb and later demolished.

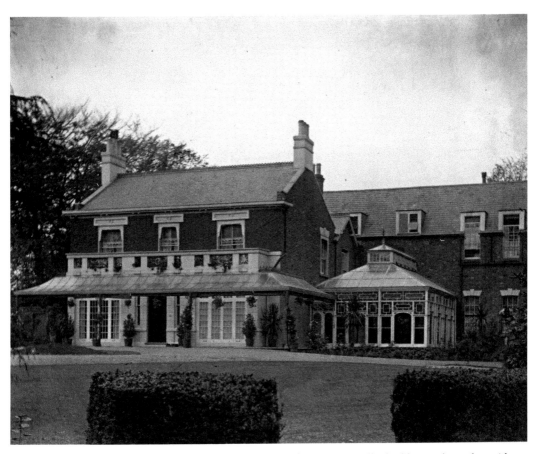

Radford House may have originated with the Spencer family as a smaller building and was the residence of silk-weaving manufacturer David Spencer until 1831. Afterwards it was converted into a Catholic school and chapel, then made residential again as Samuel Alcock left in 1852. In 1877 it was put up for let as 'suitable for a hunting family', set in 10 acres of superior turf with Radford spring in the middle. Later it belonged to the De Creeses, who sold it in 1900 to Vernon Pugh, the managing director of Rudge-Whitworth. His son Dickie's shipmate, the Duke of Kent, visited regularly. From 1918 the Pughs held cricket matches here on their own cricket ground. After Pugh's death in 1923 it was put out to let and described as having twelve principal and servants' bed and dressing rooms, two bathrooms, dining, drawing and morning rooms, a winter garden, library, billiard room, recreation room and domestic offices. Also, extensive garages and outbuildings, glasshouses, a five-roomed cottage, kitchen garden and nicely timbered and shrubbed 'pleasure grounds' with grass and hard tennis courts, a cricket field and paddock. The house, set in 8½ acres, sold in 1929 to Atkinson's Brewery, becoming the Radford Hotel. The popular pub was closed, vandalised and demolished in 2002. It is now the site of flats.

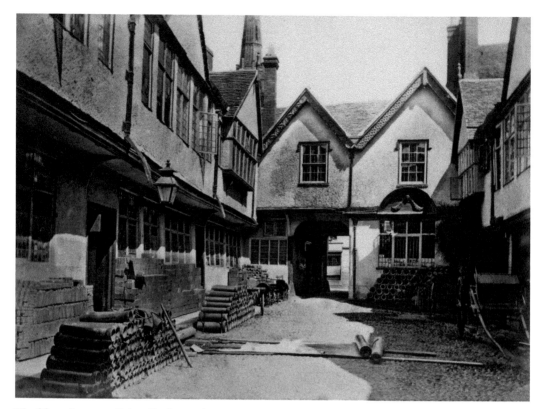

The fifteenth-century Palace Yard in Earl Street. Its most notable residents were the Hopkins family, the first being Richard, a draper and sheriff of Coventry in 1555. A Protestant, he was exiled in the reign of Bloody Mary. Richard was followed by his son Nicholas, another draper, then Sampson, Puritan mayor of Coventry and MP. During his time Princess Elizabeth was kept under guard here to protect her from the Catholic gunpowder plotters. Sampson's eldest son, Sir William, was a Royalist in Parliamentarian Coventry. He was involved in a failed plot to break Charles I out of captivity. Sampson's third son, Sir Richard Hopkins (1612–82), hosted James II here. The family left in 1781 and in 1822 a relative sold it. It then served as Miss Sheldrake's school for young ladies, the Old Golden Horse inn, and a builder's premises. Mr Ackroyd, a builder, created the name in 1850. In 1915, threatened with demolition, George Singer of Singer Cycles saved it. When George died his executors offered it with a good deal to the council, thinking they would wish to save it. They didn't! In 1918, under threat again, William Coker Iliffe said he would purchase the property 'in favour of the Corporation'. The Corporation again turned down the offer. Thereafter it was purchased with Iliffe's help by a trust led by Bishop Yeatman-Biggs. Its future was secured, and restoration began. Parts were rented out, including rooms to arts and crafts silversmith Winifred King. Fully restored, the Yard looked set for a bright future. Sadly, however, on 14 November 1940 it was flattened by high explosives.

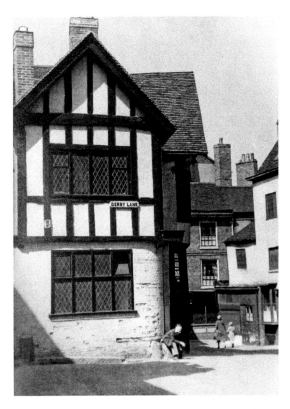

This was Coventry's smallest house: No. 61 St John's Street. The rooms measured only 5 feet 9 inches by 6 feet 6 inches. In 1930 it was rented for 3s 6d a week and consisted of two rooms – one up, one down – built over the court alley. The lower room had a tiny fire grate and the upper just a bed. It was used until the Second World War and was actually smaller than the claimed smallest house in Conwy. It was demolished in 1951 to make way for the police station.

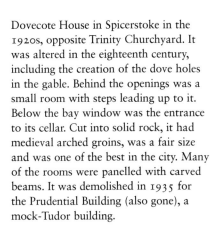

Dovecote House in Spicerstoke in the 1920s, opposite Trinity Churchyard. It was altered in the eighteenth century, including the creation of the dove holes in the gable. Behind the openings was a small room with steps leading up to it. Below the bay window was the entrance to its cellar. Cut into solid rock, it had medieval arched groins, was a fair size and was one of the best in the city. Many of the rooms were panelled with carved beams. It was demolished in 1935 for the Prudential Building (also gone), a mock-Tudor building.

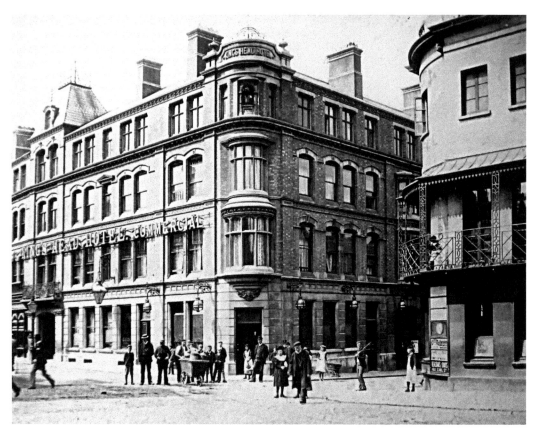

A colourised King's Head Hotel on the corner of Smithford Street and Hertford Street, overlooking Broadgate, around 1900. Opposite is the City Hotel with its fine wrought-iron balconies. This second version of the hotel opened in 1879 and it was decorated with stained glass. In the bar was Lady Godiva with Tennyson's verse, a medallion of Canute, Leofric granting a charter of freedom and medallion of Edward the Confessor. The doors in Smithford Street featured St George and the Black Prince; the first window, Edward III and Edward granting the charter of incorporation' the centre window, trial by combat on Gosford Green between the dukes of Hereford and Norfolk, with a medallion of Richard II and Henry IV and the arrest of Henry (later Henry V), Prince of Wales. Broadgate door featured the sword and mace; the Prince of Wales's feathers; Henry VI and his queen, Margaret of Anjou; Henry VII; the knighting of Robert Onley; Charles I; and Sir William Dugdale. These windows were removed during modernisation. The King's Head was destroyed by incendiaries on 14 November 1940.

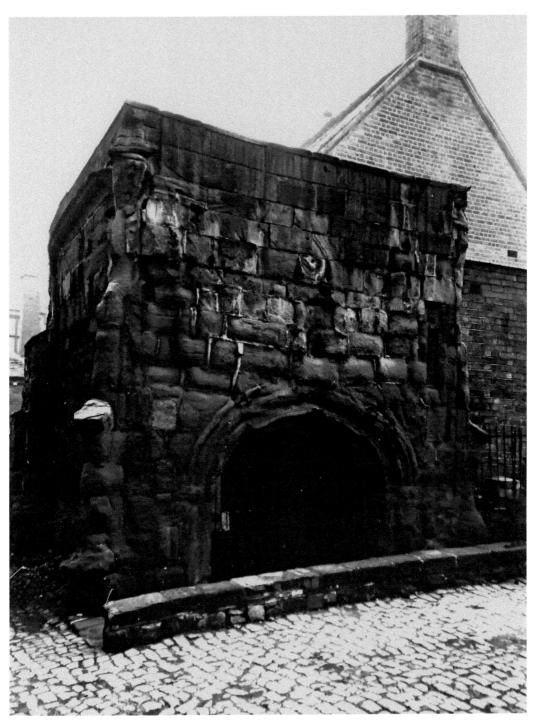

Bachelor's Gate in 1914. The archway of Whitefriars Gate led into Whitefriars Lane, which led on to Whitefriars inner gate where the poor gathered to collect alms before the Dissolution of the Monasteries. It later became known as Bachelor's Gate as it was a favoured courting place. This ancient gateway was destroyed by bombing and its site now lies under the ring road roundabout by London Road.

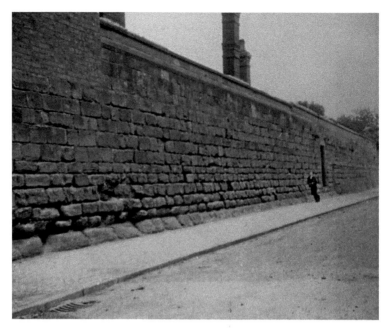

A colourised section of the city wall, which ran from Newgate to Little Park Gate and survived in Parkside until its demolition in 1928 for road widening. The road was originally a footpath by fields and allotments. It was called the 'Via Doloroso' ('the way of suffering' –from the crucifixion of Christ), this being the way the martyrs passed when being taken to their fiery ends in the Great Park. The council said the stones would be reused, but this didn't happen. The wall originally came out by the present police station.

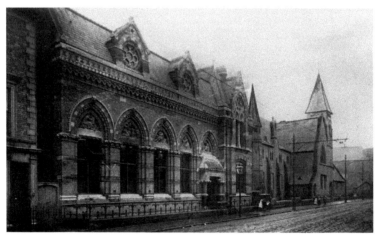

A colourised image of the Art School (opened 1863) and beyond Trinity Schools (opened 1854) in Ford Street (rear Pool Meadow) around 1911, both designed by Coventry's James Murray. The buildings served the city until the council ordered their demolition in November 1950 as stage five of building the ring road. The Art School had five carved stone Arts and Crafts panels showing aspects of art, sculpture, painting, etc. The council didn't want them, so the builder planned to put them in his garden wall. Then Ron Morgan, potter and ex-councillor, made his voice heard and they were saved. Interestingly, the builder said at the time that the council could have them back 'as long as they were not hidden away in some store place'. All except one is still in storage.

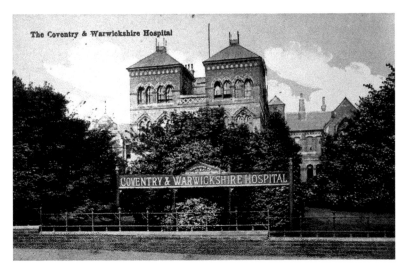

The Coventry & Warwickshire Hospital

COVENTRY & WARWICKSHIRE HOSPITAL

Designed in the Gothic style by Messrs Nevill and Son of Coventry, the original Coventry & Warwickshire Hospital on the Stoney Stanton Road (opened 1869) replaced a small building in Little Park Street. The mayor and council along with Lord Leigh laid the keystone with full Masonic rites in 1864. Attending were over twenty masters of various Warwickshire Masonic Lodges; Leigh was the Provincial Grand Master, so one can assume the masons helped fund this building, which was laid out like a cross. It only took adult patients, but in 1873 Mrs John Gulson began raising funds for a children's wing. Right into the twentieth century the hospital was supported by fundraising and gifts, and some Godiva pageants were held specifically to raise funds. The building was damaged during the war and demolished in 1948.

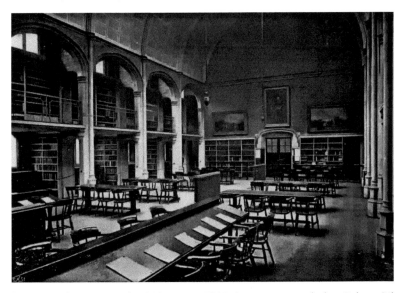

Inside the Free Library around 1900. From 1917 it was renamed the Gulson Library to commemorate the fact that John Gulson had presented the site to the city and paid for much of the building. A reference section was added containing over 20,000 books, but was destroyed on 14 November 1940. The main section, shown, survived and remained in use as a municipal restaurant. It reopened in 1956 as the Central Library, which it remained until its demolition in the late 1980s to make way for Cathedral Lanes.

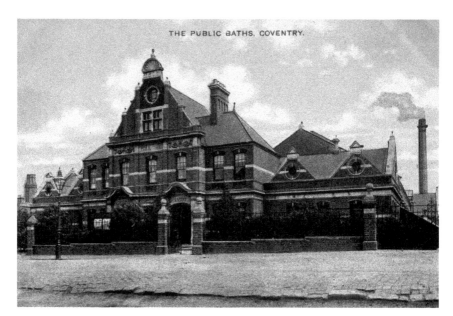

THE PUBLIC BATHS, COVENTRY.

Coventry's swimming baths in Priory Street, built in 1892. Apart from its water-based use, the swimming pool could be boarded over so the building was dual-purpose and also used as a hall. The overflow from the pool ran into the nearby Sherbourne, leading to the odd eels getting in. It was destroyed by a bomb in 1940.

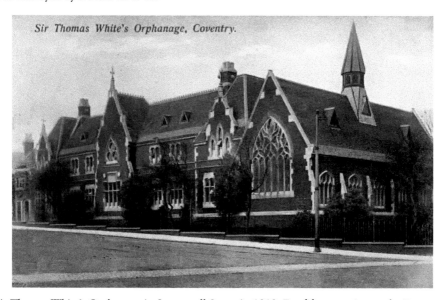

Sir Thomas White's Orphanage, Coventry.

Sir Thomas White's Orphanage in Swanswell Street in 1918. For fifty years it was the Freeman's Orphanage, but on advertisements and documents it was Sir Thomas White's Orphanage. When questioned in 1917, the Freeman admitted the money for endowing and building it came from the Thomas White charity not the freemen. In fact, over half the money the charity brought in went to the school. Six months after being questioned about this oddity it was decided to call it the Sir Thomas White Orphanage. Originally only female orphans of freemen were eligible, but it was agreed to allow other children. In 1919 it was converted into a new ward for the hospital, but it was later damaged in the Blitz and demolished.

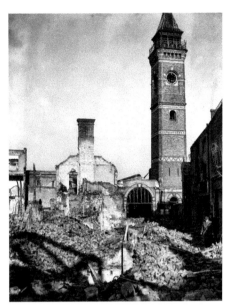

A colourised Market Clock Tower taken after the 14 November raid. The 100-foot tower was completed in 1867, and in 1870 the clock was installed. Created by Edward Thomas Loseby, it was one of the most accurate in the country. Loseby, confident in his skill, had signed a contract to pay £1 for every second it lost. The attached market building was destroyed; the clock tower survived, but it was demolished as it was claimed to be unsafe. The mechanism now runs the Godiva Clock, and its bell still chimes the hour in Broadgate. Interestingly, Samuel Corbett, who wound it daily, died on the day of its demolition.

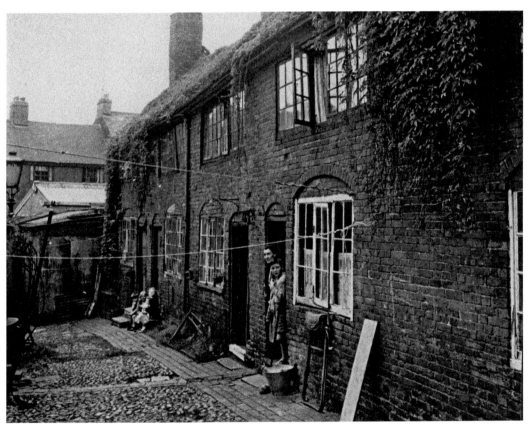

One of many of the old city courts, this is Court 38 in Spon Street, photographed in 1957. There were once hundreds of these courtyards in the city – small and large, with families sharing the same pump and toilets. The only surviving court now appears to be a section by the Watch Museum in Spon Street.

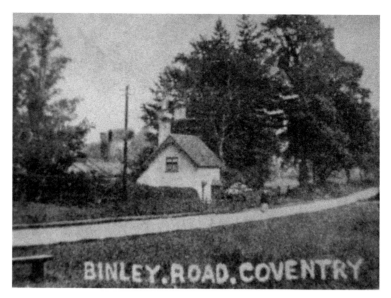

The last of the toll gates around Coventry. There were originally many, but none survive. Binley toll gate photographed around 1920. Charles Beck, the keeper, was robbed and murdered here in 1772. The perpetrators were hung on nearby Binley Common. A horse drawing a coach or chaise would be charged 3*d*, while one pulling a cart or waggon would be charged 2*d*. A horse not pulling would be 1*d*, a score of cattle 5*d* and a score of sheep, calves and lambs 2½*d*. It stood on the Binley Road by the present Mill Pool pub.

Stivichall Tollhouse on the Leamington Road around 1900. This cottage controlled two white gates – one granted access to the Kenilworth Road and the other the Leamington Road. It ceased to function as a toll gate around 1872. In 1858 Queen Victoria passed through, led by troopers en route to Stoneleigh. It is possible that the original line of Kenilworth Road turned off at Beechwood Avenue, crossing Earlsdon Avenue, and the road was realigned so the toll gate could cover two roads. This was the last of Coventry's toll gates and its demolition was approved by the council in the 1960s as it was not considered economic to restore.

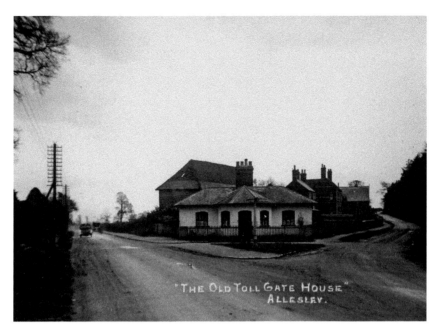

Allesley toll gate stood on the junction of Holyhead Road and Allesley Old Road, controlling both with its two white gates. Behind (left) stood an enormous ancient tithe barn in which a farm labourer hung himself in the nineteenth century. Being death by suicide, he was buried in the road just in front of the toll house. This was believed to hold the spirit in the place and stop it from haunting. The council demolished the toll gate and barn in 1931 for road widening.

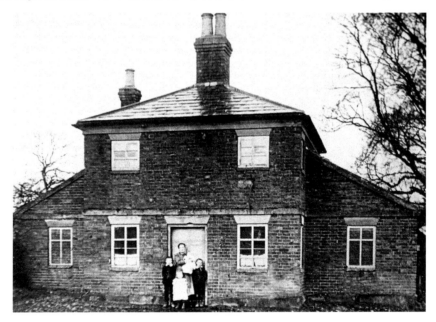

A colourised 1912 image of Willenhall toll gate, which gave the area its name – Toll Bar End. In 1848 the keeper, Thomas Lord, was taken to court and fined £2 with 16s expenses for charging a man 3 halfpence for twice crossing over the road on foot. It was demolished in September 1931 for road widening.

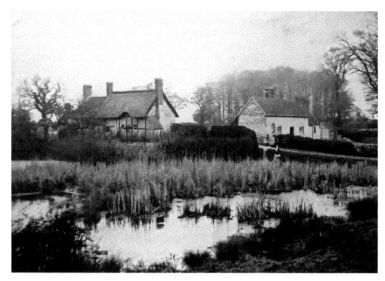

Burnt Post or Bourne Post Cottages (colourised) taken from the direction of Kenilworth Road. They stood off Kenilworth Road by the present Kenpas Highway. They are thought to take their name from a stream (a bourne) that crossed the road here and had a post to aid people crossing. A nineteenth-century resident was the 'notorious Jack Jeacocks', who was often in jail for assault. He once pulled two pistols on two police officers on Kenilworth Road and threatened them as a joke. He was locked up and given hard labour. The cottagers here made an income in the summer months selling drinks and fruit to the many who promenaded the tree-lined road. The cottages of Bourne Post were still there in 1938 but were later overrun by development.

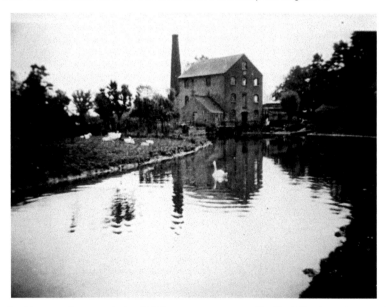

A colourised image taken in 1920 of Walsgrave or Sowe Mill off Clifford Bridge Road, which stood half in Walsgrave and half in Wyken. Built in 1859 (replacing the previous mill destroyed by fire) it was a steam and water-powered mill with a 19-foot undershot wheel for grinding barley and corn set in 3 acres of meadow. A mill had been here since the time of the Domesday Book (1086) and this one was still there in 1968, but fell to the expansion of Walsgrave Hospital.

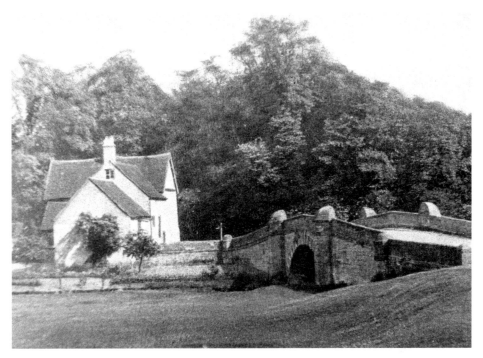

An old, colourised image of Whitley Mill taken around 1920. A mill on the site mentioned in the thirteenth century belonged to Coventry Priory. In 1849 it was owned by Lord Hood. In ruins in 1899, it was restored and occupied until its demolition in 1955.

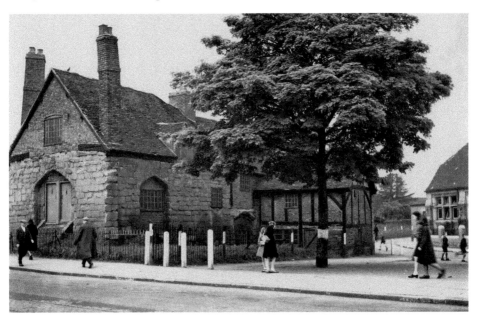

The Chapel of St James and St Christopher in Spon End, seen here photographed in 1939. Built as a fourteenth-century wayfarer's chapel, it was later used as a private dwelling. It was restored before the war but suffered minor bomb damage and was then left to deteriorate. In the 1950s the council decided to make it a 'picturesque ruin'.

3

Sport and Entertainment

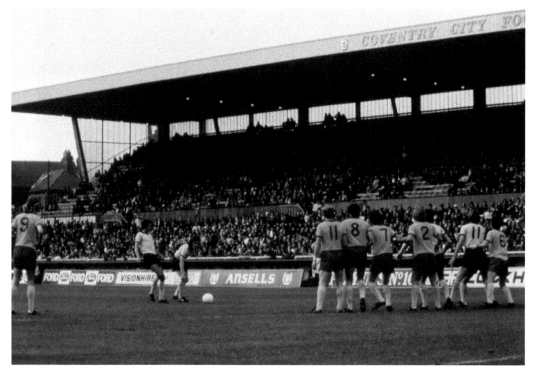

Coventry City playing Wolves in the early 1970s at the now gone Highfield Road. Coventry City Football Club was formed in 1883 by Willie Stanley, an employee of Singer Cycles. It was the Singer Football Club until 1898 when it became Coventry City. Their first pitch was Dowell's Field, off Binley Road. In 1887 they moved to Stoke and in 1899 Highfield Road. By the 1930s they were nicknamed 'the Bantams' and in the early 1960s when a new kit was brought out they were 'the Sky Blues'. On 30 April 2005 the last game was played here and after 106 years City's home was demolished and replaced with housing.

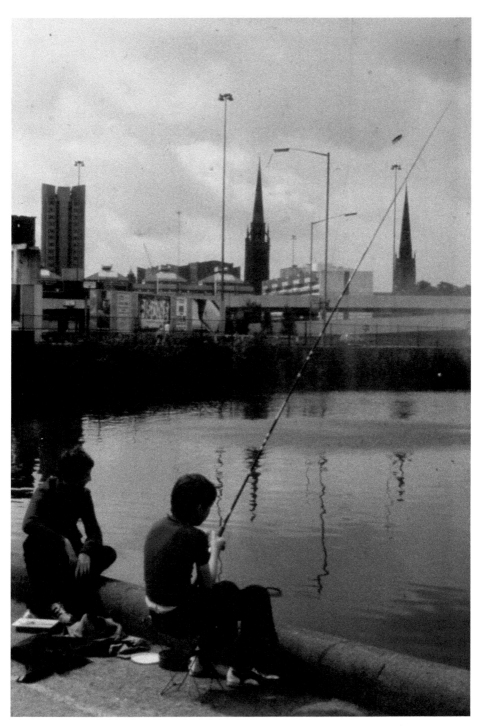

Children fishing in Swanswell Pool in the early 1970s. The Swanswell has been fished by locals since time immemorial, but not just children also adults. The pool used to contain a head of large carp, which used to feed from the warm water running into the pool from the now gone Priory Flour Mill. The Pool isn't lost, but scenes like this are now rarely seen.

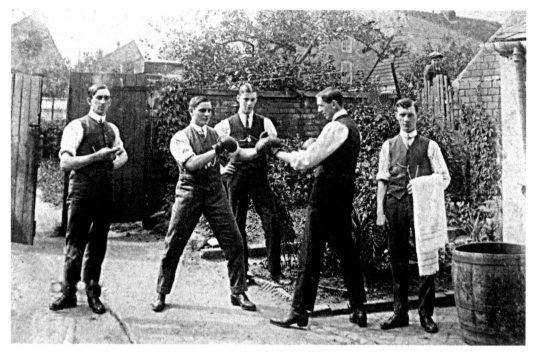

A colourised image taken around the time of the First World War. The image reflects the true amateurism of boxing years ago: people in their yard practising, unlike today when all is within the regime of a club. No doubt all of these young men ended up in other battles in the First World War.

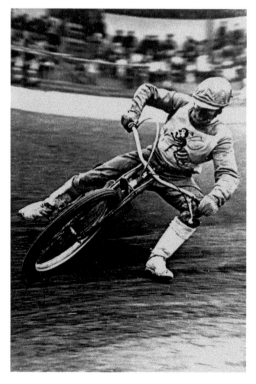

Nigel Boocock rips up Brandon in the 1960s. Boocock spent eighteen seasons with the Coventry Bees, captained England multiple times and won the British League Championship. Mr Coventry Speedway, as he was known, died in 2015 in Queensland. His ashes were returned and buried under the track. In 1969 he ranked number four in the world. Brandon Stadium opened in 1928. Thousands followed the Bees; it was one of the top teams in the country. In 2016, despite protests, the stadium was closed and housing is planned for the site. Fans continue the fight.

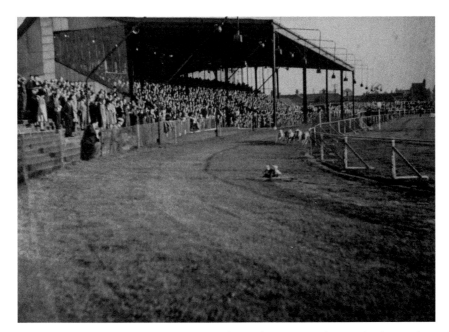

Lythalls Lane greyhound track in the 1930s. The track was opened on 7 April 1928 by Lady Dudley, the first race being the Coventry Stakes around the 500-yard track. Crowds of 7,000 were common, as were ladies in furs and gents in tuxedos. The old track and stand were overhauled and added to, and in November 1937 the new Coventry Stadium, described as having luxurious surroundings, was opened. It was closed in 1966 for housing.

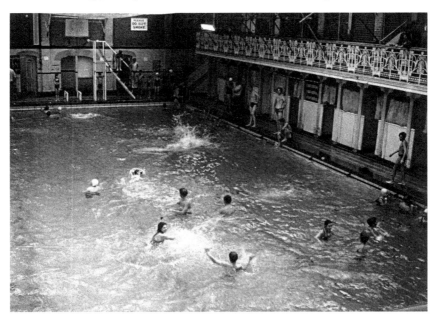

A colourised image of Priory Street Baths taken in the 1920s. Built in 1892, the baths had two pools. Notice the fine wrought-iron columns on the right and decorative balcony. The water for the baths was drawn from wells on the site of the Coventry & Warwickshire Hospital. The record for attendance of the baths in one day was 2,661.

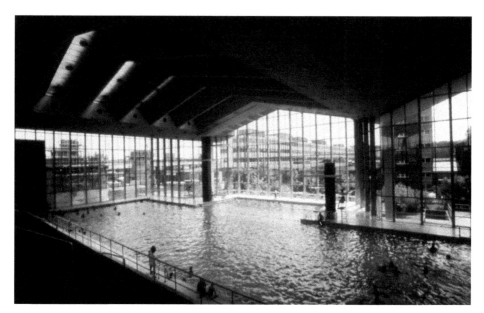

Coventry baths cost £1.3 million and opened in 1966. Standing in Fairfax Street, it was designed by Arthur Ling and Terence Gregory, who were advised by the Amateur Swimming Association. It had seating for 1,174 people and three pools: one of international standard, a main pool and one for learners. Closed in February 2020, it has been replaced by a new pool in Binley.

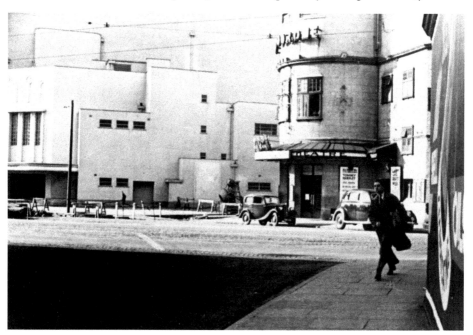

This colourised image shows the old and new Hippodromes in 1937. The Hippodrome on the right opened in 1906 – its predecessor was a tin building on Pool Meadow. In 1937 this second building was purchased by Alfred Herbert to build Lady Herbert's Garden. The new Hippodrome (left) opened on 1 November 1937, the day after the old one closed and was afterwards demolished. The new Hippodrome was demolished in 2002, creating Millennium Place.

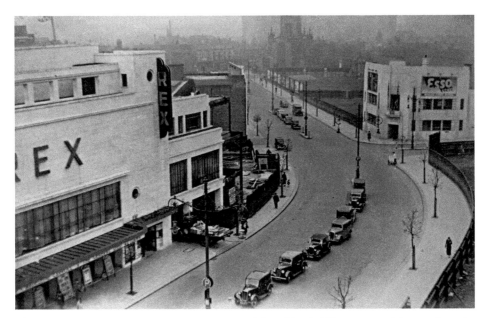

The Rex Cinema in Corporation Street in 1937. The white building on the right stood on the corner of Fretton Street (now Upper Well Street) and Corporation Street, now the corner of Belgrade Square. The Rex was the country's most prestigious modern cinemas, seating 2,550. It opened on 8 February 1937 and just before it was due to show *Gone with the Wind* was wrecked by a large bomb on 25 August 1940. Talk of rebuilding ended when it was hit again in October.

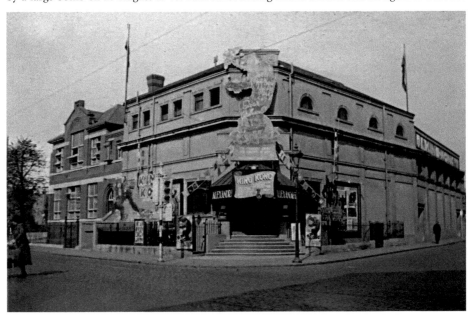

A colourised Alexandra Theatre in Ford Street in September 1933. *King Kong*, described as a miracle of modern science, ran four times a day for three weeks. It was said at the time to be 'without question one of the most amazing films the screen has ever given to the public or ever will'. The cinema held exclusive rights for 16 miles radius and was packed every day. In 1970 it was showing *King Kong vs Godzilla*. It was demolished 2018.

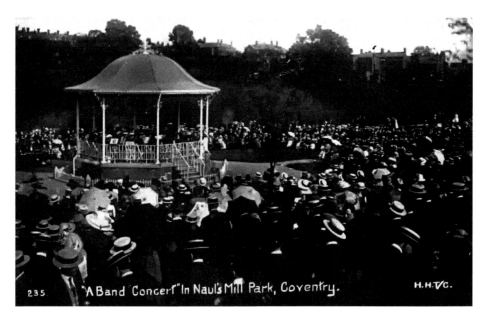

Band concerts in Naul's Mill Park were a regular event up to the Second World War. On a Saturday or Sunday afternoon or evening the park was the place to be. Many grand concerts were led by military bands that performed regularly, sometimes with choirs or dancers. Often there were two concerts a day, and the season lasted from May until September.

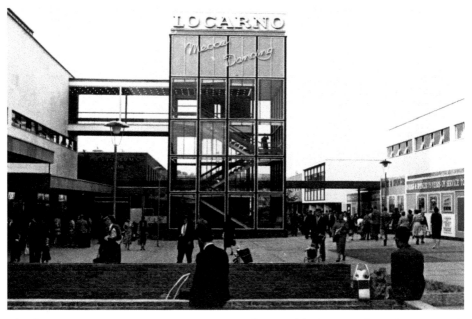

The glass tower entrance to the Locarno Dance Hall in Smithford Way in the early 1960s. Built in 1958, it was the centre of nightlife in the city centre. The ballroom had a sprung floor, making it one of the best in the country. It was a regular venue for bands (Chuck Berry's live recording of 'My Ding-a-Ling' was done here) as well as ballroom dancing and discos. Later becoming Tiffany's, it closed in 1986. The tower was demolished and the ballroom was converted into the city library.

The eighteenth-century Shepherd & Shepherdess Inn on Keresley Road, once frequented by locals, travellers and farmers, whose horses were lined up outside. Four pubs that stood between here and the city centre are now gone. This pub was lost too, but thankfully they built another in the Tudor style in 1936 behind it. The locals took their last drink in the old building and walked around the back for their first drink in the new one.

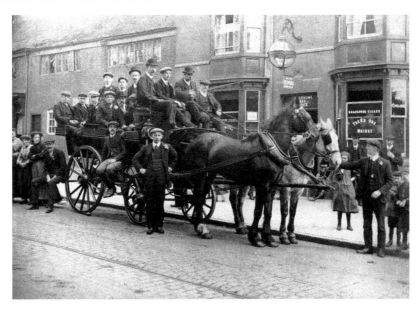

A colourised image of Hand in Heart in Gosford Street, showing an example of social life in old Coventry pubs. Many pubs rented a horse and waggon or charabancs to go on trips. This could be either the pub's quoits or bagatelle team, playing away as they often did in neighbouring towns and villages. This may be when they played quoits against the Boat Inn, Brinklow, in 1905, winning by one point.

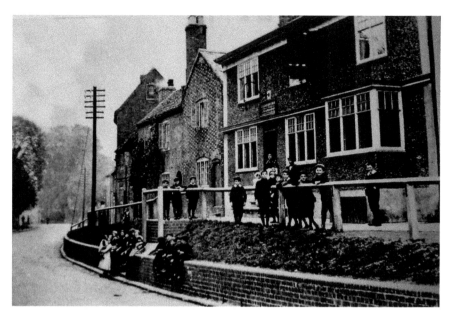

The Buck & Crown on Radford Road around 1908. Referred to as 'old established' in 1828, it was so popular in the summer that people queued to get in. Atkinson's Brewery owned all the buildings in the row and in 1928 the de-licensed pub was said to have thirteen rooms, a cellar, outbuildings and a large garden all up for let. The original intention was to demolish and build a new larger pub; instead, they acquired Radford House opposite. So we can assume that was the last year as a pub. These buildings survived until 1940 when bombs struck this corner of Radford.

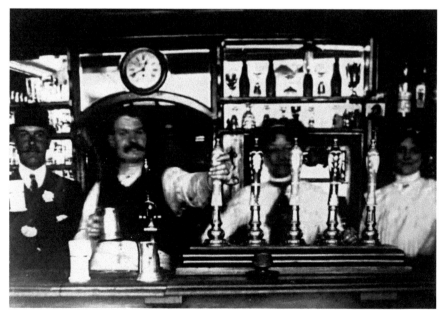

William Arnett, landlord of the Prince William Henry on Foleshill Road, is seen with his wife Ellen around 1900. The Prince was a centre of the community and stopping-off point for the canal barges that passed behind it. It was closed in 2005 and is now a builder's yard – the building survives.

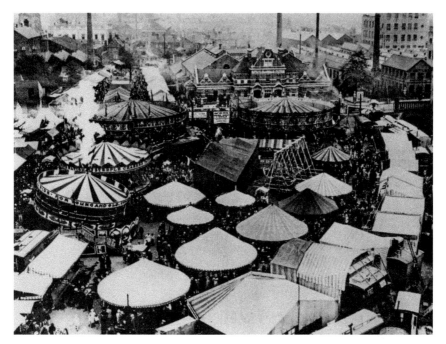

The Great Fair in Pool Meadow in 1920. Coventry held a charter since 1145 for the fair that for centuries was in Broadgate. Thereafter it moved to Greyfriar's Green and in 1859 to Pool Meadow where it remained until 1930. After this it went to Barras Heath and for many years now has been held at Hearsall Common. In the background are Priory Street baths and, to the right of it, the Sherbourne.

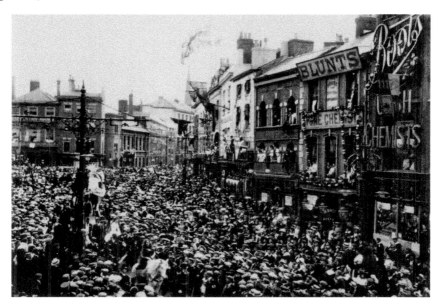

Pansy Montague rides in a packed Broadgate in the 1907 Godiva Procession on a horse called Baby. It was a great success and watched by 100,000 people. She said, 'I dimly saw my escort, and then as we met a concourse of people we heard cheers repeated again and again, and in the gladness of my heart at finding I was so cordially greeted, the tears came into my eyes.'

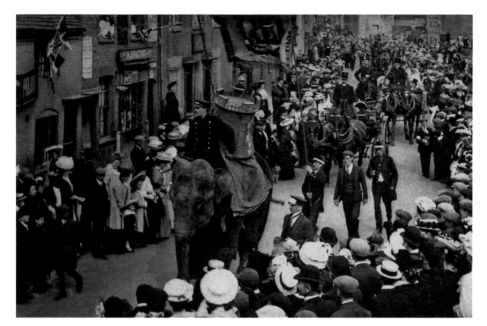

Part of the same procession, now passing the Pilot inn, Much Park Street. The elephant went where he chose and insisted on leaving the procession to get a drink, even sitting down in the road, holding it up. An adult elephant also took part in the 1862 procession.

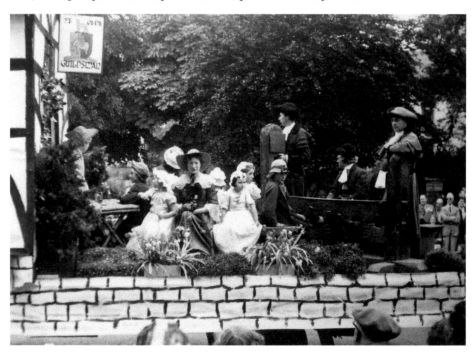

A colourised image from the 1952 procession showing the Coventry Freemen's float, which was based on eighteenth-century Coventry. Two guildsmen can be seen in the old city stocks from the undercroft of St Mary's Hall. Most guildsmen in the past were made members in the hall and since the 1940s met in its front undercroft.

4

Streets

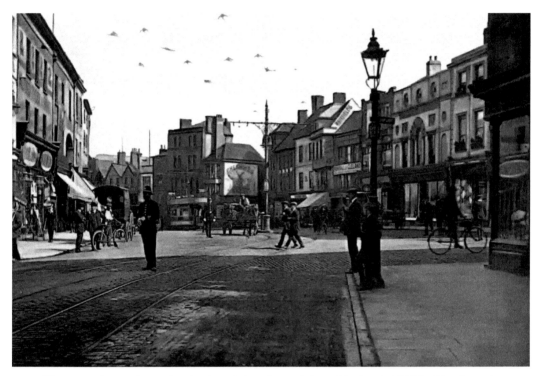

We start with Broadgate, showing how it has changed since this shot in 1912 looking from the top of Hertford Street. This broad open space bears no resemblance to today as nothing here exists anymore. The building on the right would now be the corner of the NatWest steps on the Hertford Street side. The objects in the sky are parts of the overhead cables carrying the power for the electric trams.

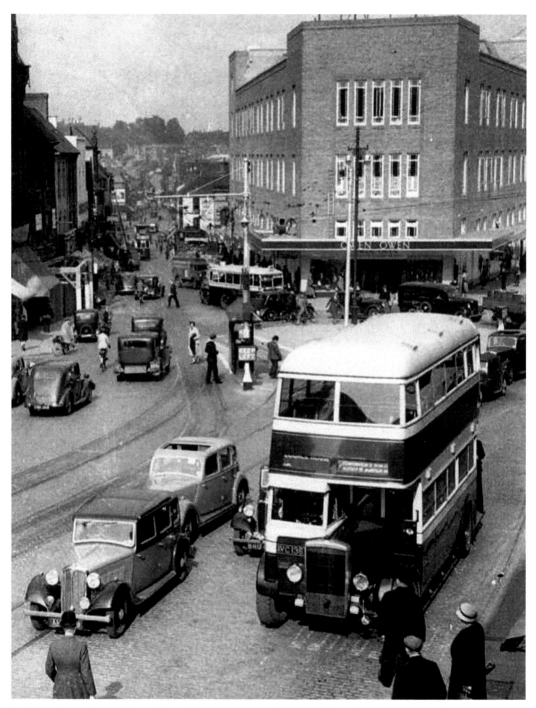

Looking down a busy colourised Broadgate into Cross Cheaping (left) and Trinity Street (right) in 1938. The upper part of Cross Cheaping and Butcher Row have been demolished and the city's first big store, Owen Owen, opened in 1937. It stood for three years before being gutted by incendiaries. Most of the vehicles are Coventry made, including the Daimler bus purchased in 1937. The white shop behind Owen's is the only one to still exist –Forbidden Planet.

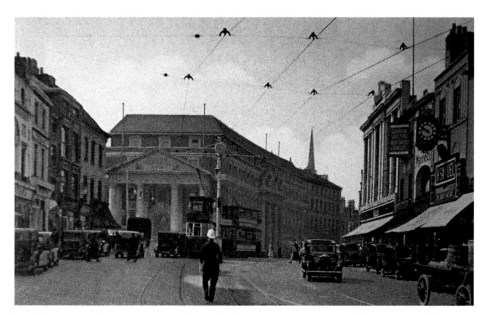

Looking up Broadgate towards the NatWest bank around 1936. A white-gloved and helmeted policeman walks down to start duty on traffic control at the crossroads. With this photograph we see an existing large building: NatWest, built 1929/30. Note the line of the Bank Chambers and Post Office curving down Hertford Street, a view mostly lost behind Broadgate House.

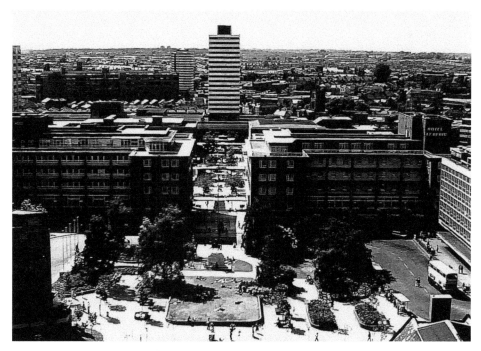

Broadgate in the late 1970s. The road nearest the photographer is gone and Broadgate has been partially pedestrianised with more trees and planting. The area out of shot below was cleared of its temporary shops, excavated and grassed over, with an ancient well made a feature. Most of the foreground now lies under Cathedral Lanes. Beyond is Ling's Mercia House.

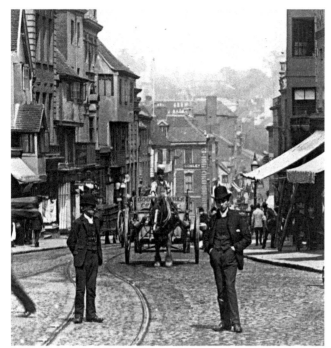

A colourised view of Cross Cheaping and the Burges around 1905. Behind the two smart young men is a waggon with 'Coventry' carved into the backboard, and beyond is Comley's furniture shop. Hardly noticeable on the right next to the lamp post is the street's noted clock, which supported a huge clay pipe from when it was Bank's & James Tobacco Manufacturers.

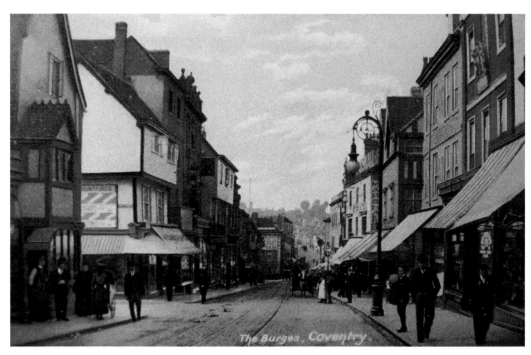

The Burges in 1905, a mix of medieval and Tudor. Most of the buildings on the right were refaced in the early nineteenth century. On the left is Ye Olde Talbot Inn, named after the fifteenth-century hero John Talbot, the English Achilles, who watched his son made Lord High Treasurer in 1451 in Coventry Priory. Here you could get cooked beef and sausages from Davies's or get pork pies from Mrs Jephcott, an old lady who dressed like Queen Victoria. The white building stands at the entrance to West Orchard.

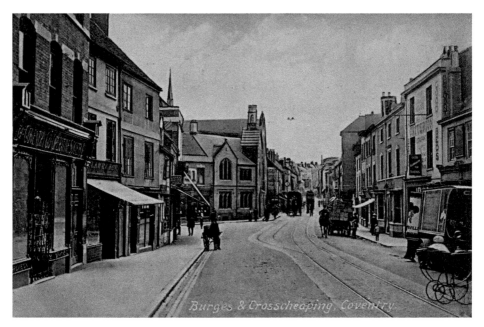

A busy Bishop Street looking back towards the Burges in 1912. First on the left can be seen the Coventry Building Society and next door is Lawrence's pipe and tobacco shop, established back in 1846, and opposite is the Criterion Restaurant. On the left (the big number 31 in Silver Street) is C. W. Thompson, tailor.

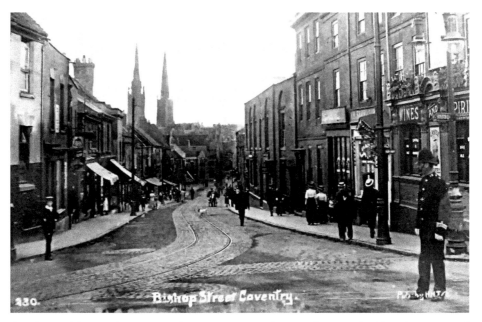

A colourised image showing a policeman on point duty at the top of Bishop Street around 1906. The pub on the right is the Castle Hotel, run by Thomas Strong. The policeman, possibly PC Dreghorn, was there because this was the junction of five streets: Bishop Street, St Nicholas Street, King Street, Leicester Street and Leicester Row – six if you include Radford Road, slightly higher up.

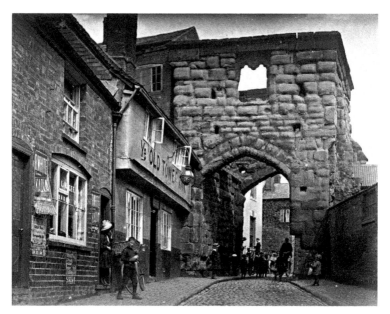

A colourised 1910 image of Cook Street Gate and Ye Olde Tower Inn with J. H. Pratt, landlord, with baker L. R. Gee next door. All the ancient buildings around the gate except the Elizabethan Tower inn were demolished. The inn had older origins as a guardhouse as it had its own doorway into the tower. Mitchells & Butlers were offered a substantial sum in 1915 for the building but turned it down, preferring to present it to the city and thinking it would be preserved – it wasn't. In July 1963 the Olde Tower Inn was demolished. Here in 1839 the locals formed the Burial Society, a national foundation.

A group of early eighteenth-century cottages in Leicester Street in 1926. These are typical of many that existed in the side streets of Coventry and have since been lost to the bulldozer. The council demolished twenty-two of these cottages in 1926, describing them as slums or 'working class dwellings'. All of the streets in this area were demolished.

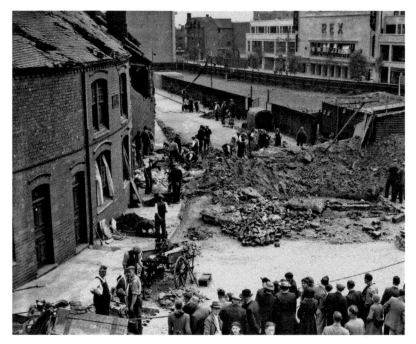

Well Street, a typical Victorian street in the middle of Coventry. Half of it had been demolished by 1928, and in 1935 nineteen more. In the enclosed space at the rear the Broadwell was unearthed, a conduit fed by two springs coming from the rock dating from at least 1333. It was oval, lined with oak and used until 1855. When uncovered in 1933 it was pumping 120,000 gallons of spring water a day; this now runs into the drains. In the background in Corporation Street stands the Rex. Parts of the street were still being demolished in 1964 – some buildings dated to the sixteenth century.

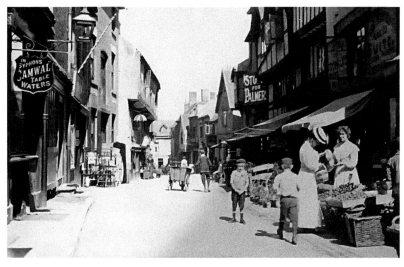

A colourised image of Butcher Row around 1900. The buildings on the right basically follow the line of the plant bed outside Holy Trinity Church. This was one of Coventry's most-loved streets, which despite objections was destroyed by the council in 1935/6 to create Trinity Street, giving easier vehicular access to Broadgate.

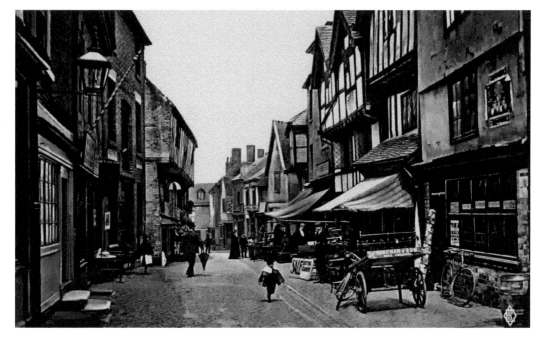

Another view of this much-loved street. What can you say, what a gem this would have been if it had been allowed to survive.

This is Trinity Lane, taken from the graveyard of Holy Trinity. It is, in reality, the rear of the shops on the right in the previous two photographs.

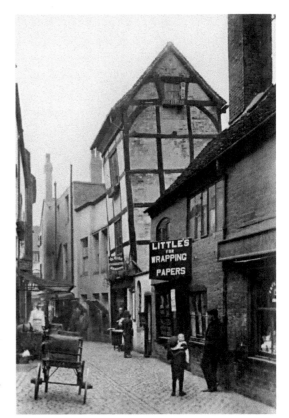

A colourised image of Little Butcher Row looking towards Butcher Row in 1910. This lane was demolished at the same time as Butcher Row. The unusually tall, timbered building was the Olde Curiositie Shoppe, an antique shop. This ran parallel to the back of the present Primark.

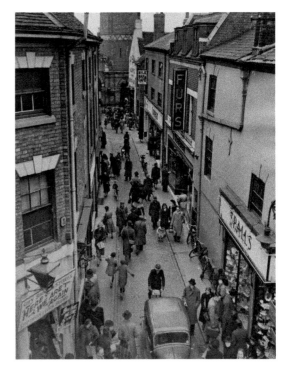

Looking down Market Street towards the Market Clock Tower in 1940. If you turned right at the bottom in Market Place you would come out in Broadgate. This entire area, apart from the Market Clock Tower, was bombed on 14 November.

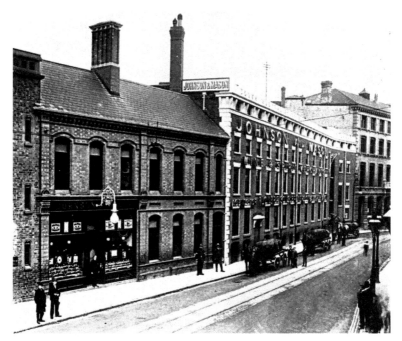

A colourised image of Hertford Street in the 1890s. The rear building survives; it is the old post office, now a Chinese supermarket. The top floor was burned out in the Blitz and removed. In the foreground is Johnson & Mason's, wine and spirit merchants. They also sold beer, supplied by Flowers of Stratford upon Avon. All except the post office (originally Cash's) was demolished in 1928/9 to build the National Westminster Bank and the Bank Chambers.

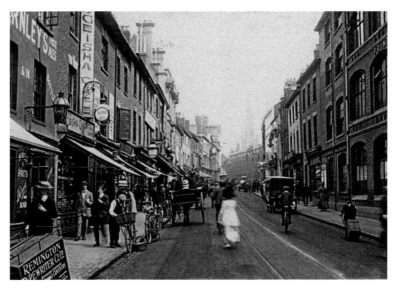

Hertford Street in 1905 with Johnson & Mason's on the right. The large building jutting up opposite was the Corn Exchange, later the Empire cinema, now the Empire. In the foreground, to the left, is the Geisha Café. Parts of this street were demolished before the war and part was destroyed during the war. The lighter-coloured Georgian building, which lost its top floor during the war, was demolished last year. The shops below the café were demolished in 1961.

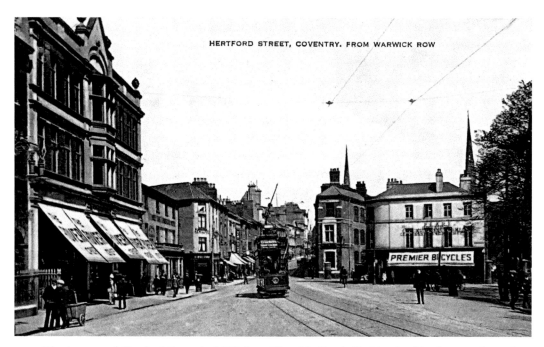

The bottom of Hertford Street in 1912 from Warwick Road. Nothing in this photograph survives. Hidden away under the modern bricks is what was the Litten Tree pub (left), the remains of the Old Rover Showrooms, which are now scheduled for demolition. Next door is the original Three Tunns inn.

The Wesleyan Chapel in Warwick Lane, opened in 1836, photographed in 1934. Next door is the chapel's Sunday School, which opened in 1892. The chapel had a close call in 1908 when its tall chimney was struck by lightning smashing through the roof. It was replaced by the Central Hall in 1932.

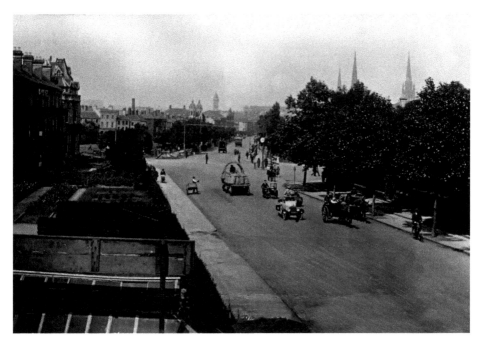

Looking down a wide Warwick Road in 1928. It was widened in the nineteenth century to create a grand vista approaching the city from the station, but this was drastically changed with the building of the ring road. Most of the area in the foreground is now car parks.

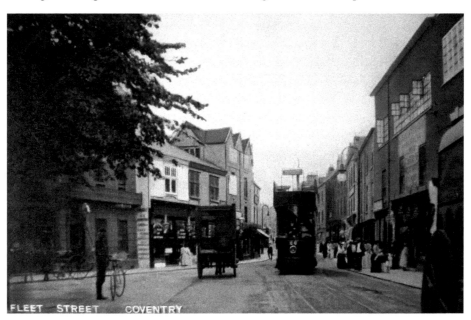

Looking from Fleet Street into Smithford Street in 1912. Behind the cyclist is St John the Baptist Church. The tram is going straight up Spon Street, and on the left the horse gig is heading up Hill Street. The tall building to the left is the George IV inn and on the right are watchmaker's workshops. Part was demolished for Corporation Street in 1928/9; more came down in 1958; and the Tudor George IV was demolished in 1963/4.

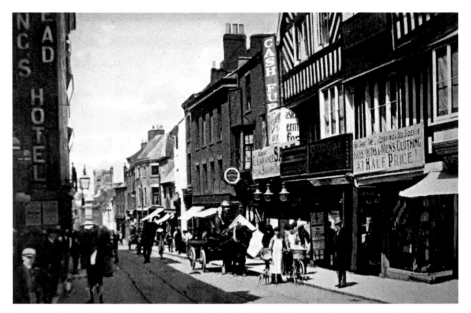

The top of Smithford Street in 1905. The large fifteenth/sixteenth-century timbered building on the right, Lion House, was originally an inn, later a clothing warehouse and then tobacco warehouse. It housed Peeping Tom from the demolition of the old King's Head until its rebuilding in 1880. Among its richly carved beams it had a painted oak white lion which came from the Red Lion in Hertford Street. The rear of the building was apparently older with a massive winch for lifted wine and beer barrels.

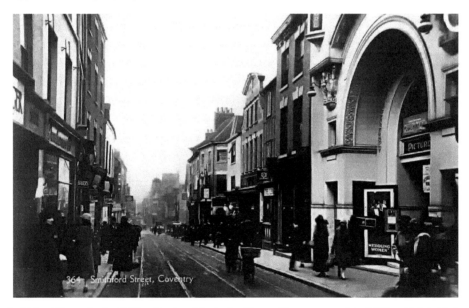

Smithford Street in the 1920s. On the right is the Picture House, opened in 1911, which held the sole rights to Kinemacolor in Coventry, described as the actual colours of nature. Widening of the street was approved in 1930 and demolition and rebuilding started with Woolworth's and Marks & Spencer. The work hadn't finished when it was wrecked in the Blitz. Buildings still survived in the street while the precinct was under construction.

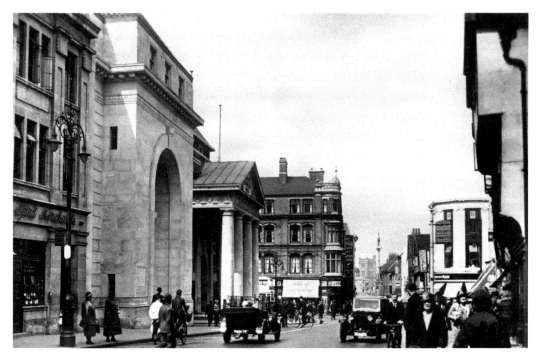

A colourised High Street looking into Broadgate in the 1930s. This had been a narrow, congested street in the 1920s until its widening in 1929 with the demolition of timbered buildings. Lloyds, NatWest and Waters remain. Beyond the King's Head pokes out.

The street again before widening, showing the narrowness and congestion. Problems such as this came with a growing population. Parts of the city simply couldn't cope.

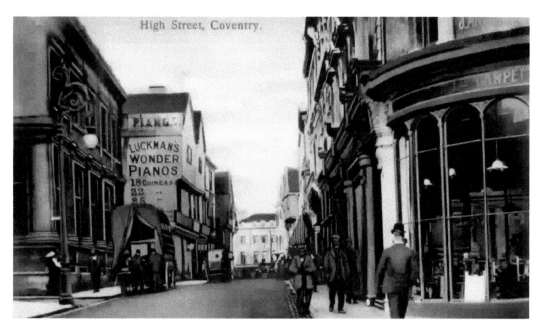

The same view showing the corner of Hay Lane (right). This is before the population rise (around 1910), showing a rather leisurely scene.

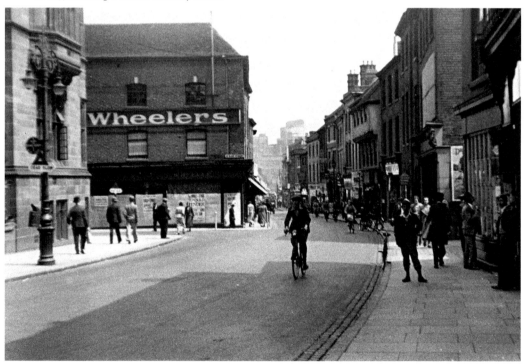

Down Earl Street into Jordan Well around 1920. The Council House, started in 1912, is set back, and the cellars of the buildings that stood here lay buried under the pavement. Many of these buildings dated back centuries. Opposite Wheelers the three-storied timber building was probably the Old Star Inn – its medieval cellar survives.

A wonderful, colourised view of Jordan Well. Its demolition was first mooted by the council in 1938 and although some buildings here fell in the Blitz a large number survived. The buildings on the left survived but were demolished after the Herbert opened in 1960.

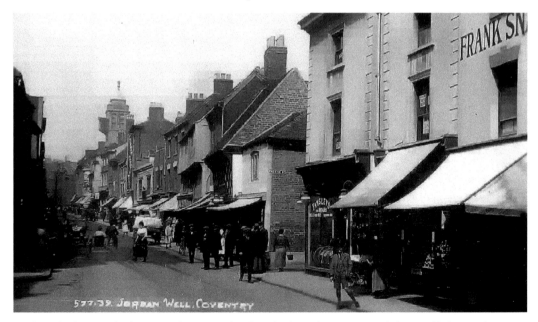

Looking back towards the Council House. The drop back in the pavement (left) is still there today but only the Council House survives. Compulsory purchase orders were sent out in 1955 and most were demolished in the 1950s, 1960s and later. The ancient Old Dun Cow Inn was demolished for the polytechnic along with No. 40, a 1325 hall house with a unique roof.

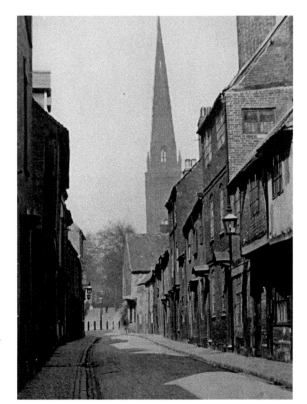

New Street, looking towards the spire
of Holy Trinity around 1930, is said to
have been created to house the builders
of St Michael's in the fourteenth century.
Hidden below brickwork stood many
ancient buildings that were cleared
for the Lanchester Polytechnic, later
Coventry University.

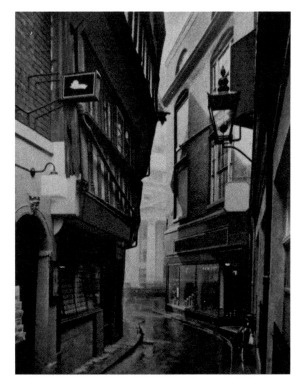

Looking down Pepper Lane towards
the High Street with NatWest showing
through the gap. A Georgian building
stands on the right and an Elizabethan
building on the left, demonstrating how
narrow some streets were.

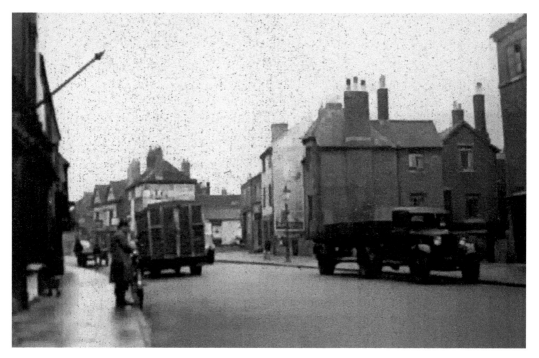

A blurry, colourised, rare image of the bottom of Much Park Street nearing London Road as it appeared in 1933. This was the entrance to the city in the days of stagecoaches. Some buildings in the street fell to bombs, but most were demolished by 1971 for the ring road.

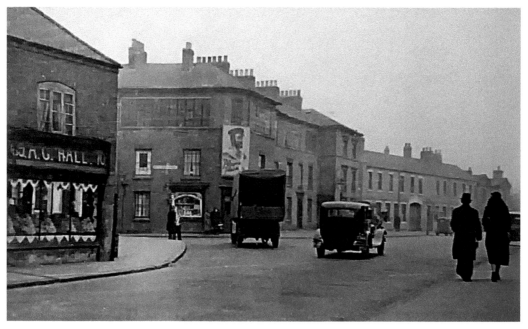

Another rare, colourised image of the junction of Much Park Street, Whitefriars Street, Gulson Road and London Road in 1933, again cleared for the ring road. The car turning in front of the couple is going onto London Road.

5

Industry

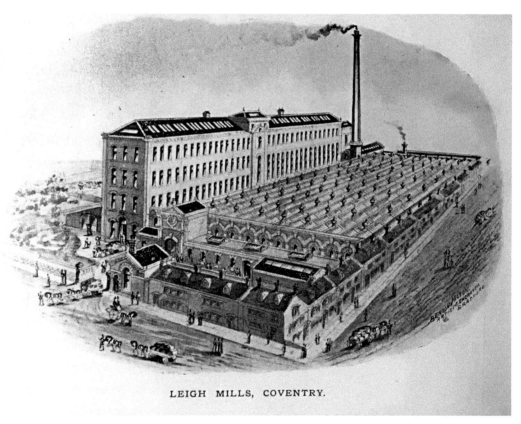

LEIGH MILLS, COVENTRY.

Leigh Mills in Hill Street in 1890, founded in 1864 by Lord Leigh of Stoneleigh to help unemployed weavers. The mill had a massive 26,000-square-foot floor space and was a worsted spinner and manufacturer. Although still running at a profit, it closed in 1963 as the council wished to acquire part of it for the ring road. The firm reluctantly sold up and moved to Yorkshire, where it still trades. Demolished in 1963, its gatehouse is a pub.

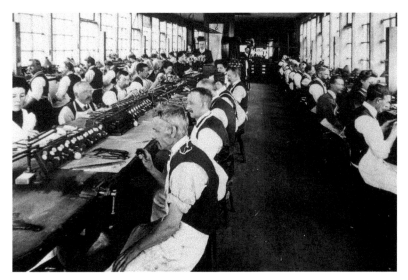

Coventry was one of the main watch manufacturers in England. This colourised photo is of the workshop of Rotherham's, watch and clock manufacturers in 1907. John Rotherham was in the trade in 1810 and Richard Rotherham was recorded as a watch manufacturer in Spon Street in 1813. Rotherham's, as a single manufacturer, came after 1822. They stopped making watches in 1930 and clocks in 1964. Charles Dickens came to the factory in 1858 and was later presented with a watch that he carried all his life.

Coventry was once the world centre of cycle manufacturing, which was down to James Starley, the 'Father of the Cycle', who produced the first cycles here. This is Starley Bros, St John's Works, Queen Victoria Road in 1896, one of Starley's later factories. Starley set up this factory with his brothers in 1875, later producing the popular Psycho and Starley racers and roadsters. Around 300 workers produced thousands a year. In 1902 it was converted into the Drill Hall with rifle range for the 2nd Volunteer Battalion Royal Warwickshire Regiment. The building survived into the 1970s and despite a campaign to save it, it was demolished and is now a car park.

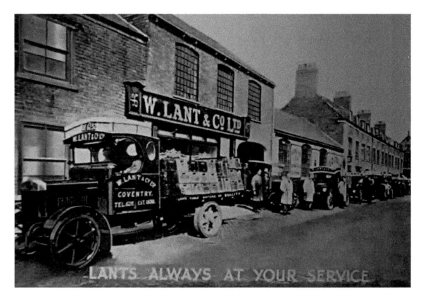

W. Lant & Co., mineral water (pop) makers in Bond Street around 1905. The last bay of Bonds Hospital can be seen beyond in Hill Street. I assume this photo was taken to advertise Lant's new fleet of vehicles as they previously used horses. By the 1960s it had become R. White Lant Ltd and in 1964 the council took it over, then gave it over to development. R. White Lant left the city, and the factory was demolished for a car park – now flats.

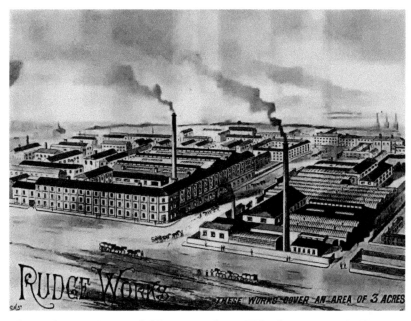

The Rudge works in 1898. Founded by Dan Rudge at Wolverhampton in 1869/70 it moved to Coventry in 1880. In 1894 the Rudge Cycle Co. was amalgamated with Whitworth Cycle Co. Its huge six-storey factory in Crow Lane was a Coventry landmark, though all are now gone. The firm enjoyed an international reputation throughout its existence. During the late 1920s and 1930s Rudge motor cycles were highly successful in British and Continental racing and it remains a famous name today.

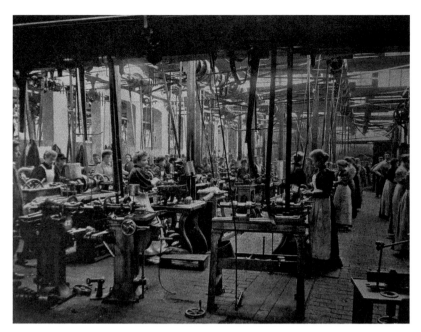

Women in the Coventry Machinist Cycle Works, formerly the Coventry Sewing Machine Company, in 1898 on Quinton Road/Mile Lane. James Starley was foreman here in 1867 when the firm made sewing machines. In 1870 he left and set up the St John's Works, making cycles after his first experiments with them in this factory. This factory continued under Rowley Turner making sewing machines and in 1891 produced the Swift and Club cycles. In October 1896 it was taken over by the Swift Cycle Company, who continued until 1932 with cycles and later motorcycles and cars. A small section remains.

A colourised photo of workers in an unknown factory in Coventry around 1920. Note the straps running from the ceiling down to drive the lathes. This works, like many in the early twentieth century, were still driven by steam engines.

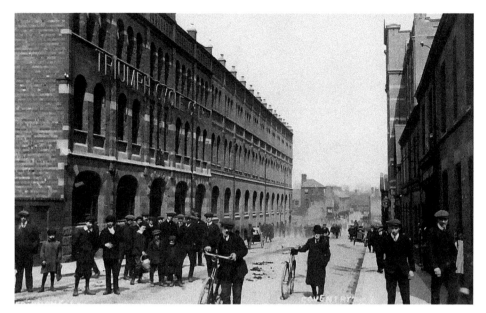

A colourised image of the Triumph factory, below St Michael's Church in Priory Street, around 1912. Founded by Coventry mayor Siegfried Bettman in 1885, he acquired this old spinning mill in 1902 and produced cycles and motorcycles. They also acquired a factory in Clay Lane where they built their first car, the Triumph 10/20 in 1923. This factory was in use until 1936 when they opened the Holbrook Lane plant and in 1948 the Torrington Avenue factory in Tile Hill. Famous for its cycles, it later gained an international reputation for motorcycles and cars.

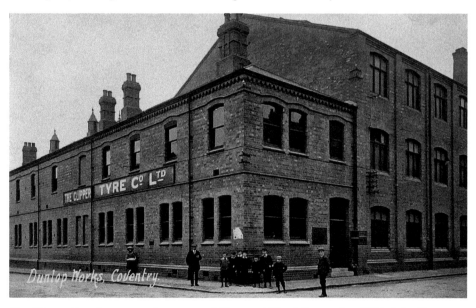

The Clipper Tyre factory on the corner of Alma and Hood Street after 1901. John Davenport Siddeley was sent to Coventry by the Dunlop as their representative but instead set up the Clipper Tyre factory. By 1901 he had decided the future was in motor car manufacturing and sold his premises to the Dunlop – hence the two names. The Dunlop outgrew the site and moved to Whitmore Park and Prologis Park, Keresley.

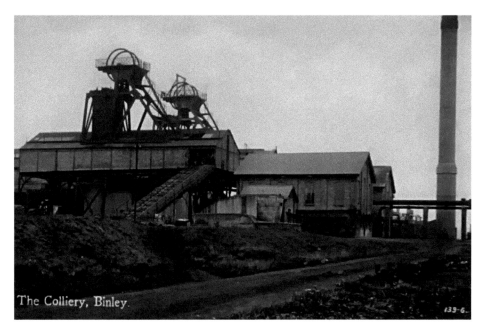

The Colliery, Binley.

Binley Colliery, Willenhall Lane, taken in 1960. The shaft for the pit was sunk by Scottish coal masters Merry & Cunninghame Ltd in May 1907. By 1924, 500 worked here, including many Scots, who formed the original workforce. Closed in 1963, it left a mountainous spoil heap and Binley village with a population of 3,028, the majority of whom were connected to the pit.

In 1917 the Warwickshire Coal Company hit a seam at Keresley village, starting over sixty years of coal extraction. The pit produced millions of tons of coal until it closure in 1991. British Coal was condemned and 1,300 lost their jobs, with over 400 million tonnes of coal still in the ground. It is now the site of Prologis Park.

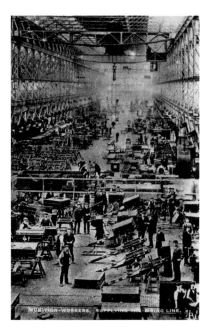

The gun carriage shop at the Ordnance Works in 1916.
In 1911 the works in Red Lane was put on the Admiralty
and War Office list and began to manufacture ordnance. It
was taken over by Mulliner, carriage builders, and in 1903
sold to Cammell, who restarted producing military and
navy ordnance. In 1906 it became the Coventry Ordnance
Works, producing field guns, huge naval cannons (firing
22 miles), shells, torpedoes and ammunition trailers. It was
sold to the navy in 1938 and closed in the 1970s, becoming
a housing estate.

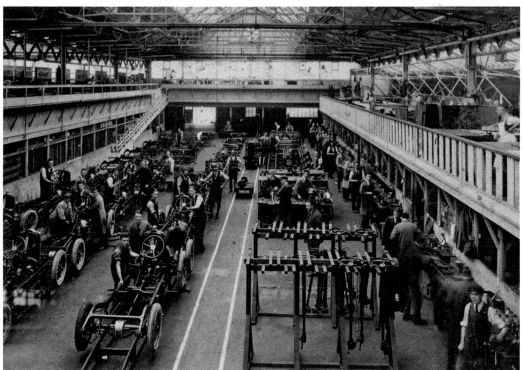

The Standard assembly shop in 1927/8 in Canley. The Standard Motor Company was founded
in Coventry in 1903 by Reginald Walter Maudslay. For years it built the Ferguson TE20 tractor,
powered by their own Vanguard engine. Standard's tractor assets were sold to Ferguson in 1959,
and in 1945 Standard purchased Triumph and in 1959 changed to Standard-Triumph. The
Standard name was last used in Britain in 1963.

A colourised image of the Daimler factory off Sandy Lane, Radford, in 1920. The first motor cars were built nearby at the Great Horseless Carriage Company and Daimler. Daimler opened this extension before the First World War. Here military vehicles, tanks and aeroplanes such as the Daimler BE12 fighter were built. Daimler merged with Jaguar in 1960 and produced under the title Jaguar-Daimler until the mid-1990s. It was then closed and developed into a housing estate in 1999.

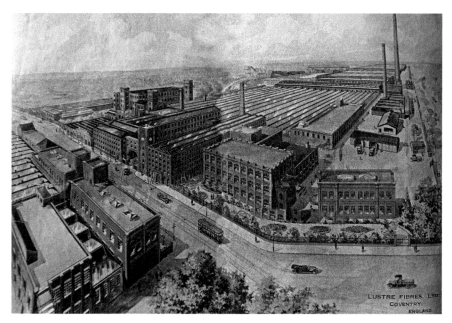

Courtaulds, Foleshill Road, in the 1930s. In 1904 they built the world's first factory to produce artificial fibres here. Called Rayon, it was made from cotton waste and wood pulp. The factory was served by a private siding part of the Foleshill Light Railway. It was enlarged and eventually became the world's largest manufacturer of artificial fibres; it also diversified into carbon fibres and specialist plastics. It was demolished in 2015 for housing and part of the frontage remains.

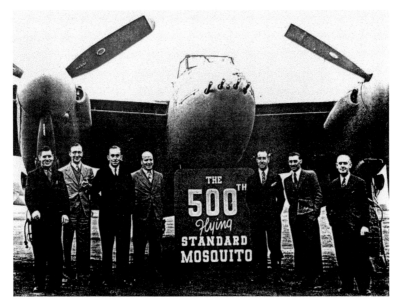

During the Second World War the Standard eased off on the production of motor cars to concentrate on producing the iconic Mosquito 400-mph fighter/bomber, a remarkable two-engine attack plane. Over 2,000 of these amazing wood and canvas machines were built here.

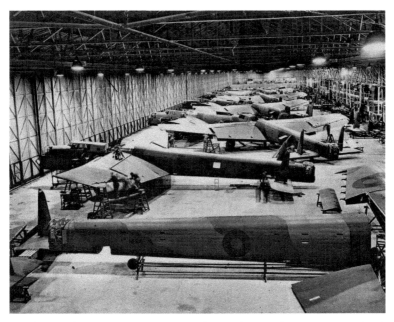

Building Whitley bombers in 1939. Armstrong Whitworth Aircraft at Baginton and Whitley was for years the centre of aircraft production in Coventry. The company, who moved to Whitley from Parkside, began producing the Siskin – the RAF's main fighter plane. In 1927 they produced the Atlas biplane and in 1926 the Argosy airliner. In 1936 they built and flew the Whitley bomber from here, which became the RAF's main bomber. As the war continued they opened a second factory nearby at Baginton, where they produced other bombers including the Lancaster. Production of aeroplanes and missiles continued here until 1965.

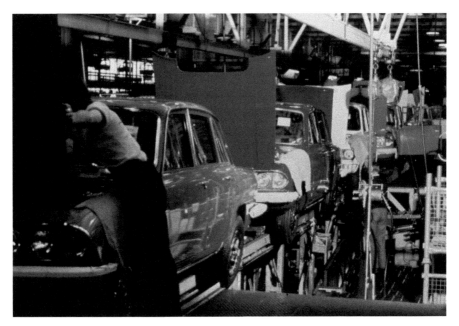

Production at the Standard Triumph factory of the Triumph 2000 Mk 2 saloon around 1965. It was designed by Giovanni Michelotti and came onto the market in October 1963. The Canley factory closed in 1980 and is now shops and an industrial complex.

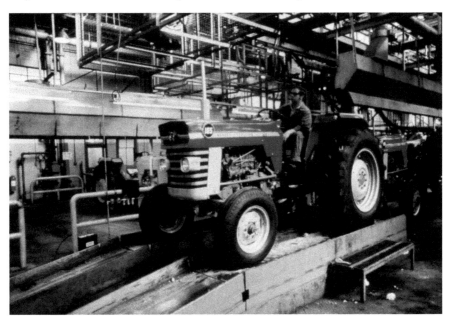

The Massey Ferguson factory, Banner Lane, Eastern Green, occupied a former Second World War shadow factory site. The Standard Motor Company moved in after the war and began producing tractors with the Ferguson name – TE20s. Meanwhile, Harry Ferguson Ltd changed hands and became Massey Ferguson. In 1959 the Standard ended tractor production and Massey Ferguson took over the factory. Massey Ferguson grew in a global operation with Banner Lane as their European headquarters. The factory closed in 2002 and is now occupied by houses and shops.

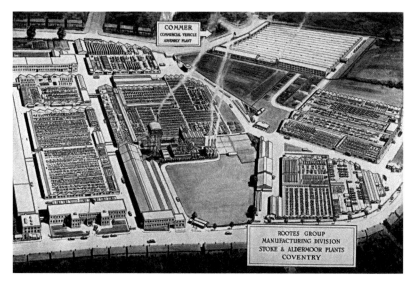

A colourised image of the Stoke and Aldermoor plants of the Rootes Group, off Humber Road. Originally the Humber factory, 60 per cent shares were acquired by the Rootes brothers in 1928, giving them controlling interest. The brothers joined the Humber board in 1932 and began to make Humber the holding company for their Rootes Group. The company also took in Singer and Hillman and produced many well-known cars such as the Snipe, the Humber Hawk and the Super Minx. In 1966 the company became the Chrysler Group and in 1979 was sold to Peugeot, who left in 2006, leaving nearly 3,000 Stoke and Ryton workers jobless. The site is now a housing state.

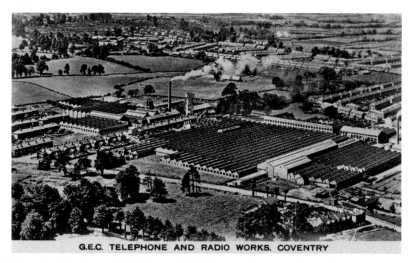

The GEC works (the former Peel Conner Telephone Works) in Stoke in the 1940s. In 1915 the General Electric Company (producing telecommunications equipment) bought the Copsewood Grange estate and in 1921 liquidated Peel Conner and moved to the site. In 1939 the old Rudge in the city centre and Wickmans were taken over by the firm for war work, such as two-way radios for RAF fighters and equipment for night fighters. The old Rudge/GEC factory was demolished in 1992 and when the Stoke plant closed in 2013 the council approved 329 houses on the site. Copsewood Grange itself was at risk, but was rescued and restored due to the pressure of the Coventry Society.

6

Moments in Time

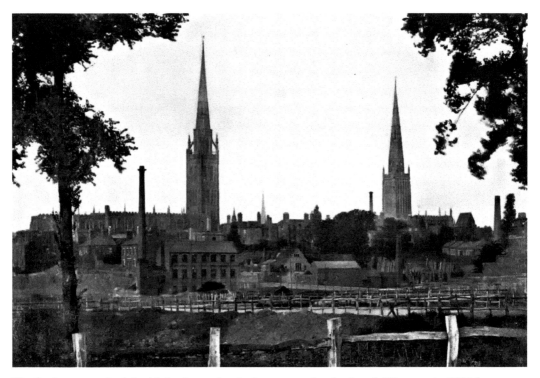

The furthest we go back in this book: a colourised moment taken by Joseph Wingrave in 1860 from the fields below St Peter's Church looking across Ford Street where elms and cornfields flourished. The chimney belongs to the Reed and Slay factory and right of it is Newark's wood yard with the River Sherbourne running from left to right past it. Behind is St Michael's (left) and Holy Trinity(right) and between is the spire of Christchurch.

By 1915 Pool Meadow was a flat, open area, a gathering place for large meetings, including the annual fair. At the edge of this, hidden from view, is the Sherbourne.

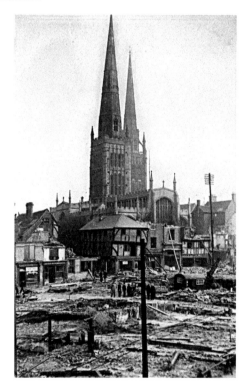

A colourised image showing the destruction of Butcher Row and its surrounds in 1936, demonstrating the obliteration of some of the city's most picturesque streets. The most photographed area in the city is suddenly a slum, cleared for modern development.

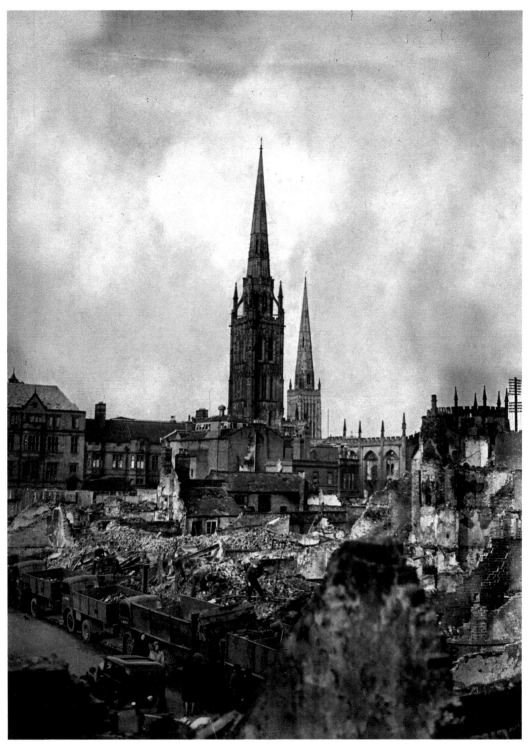

More destruction – this time by bombs. This colourised image taken in November 1940 looks past trucks parked in the wrecked part of the upper part of Jordan Well and towards the spires.

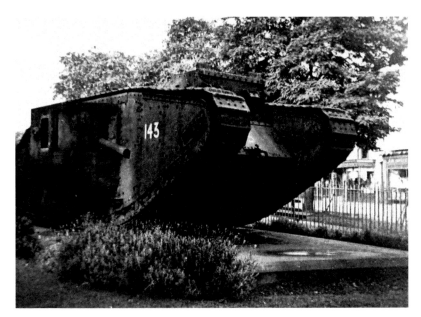

This 35-ton, 125-hp tank built at the Daimler works was placed on Greyfriar's Green near the Thomas White statue in January 1920. It was presented to the city for raising £8.5 million for the war effort. By 1937 it was decided to remove it. On inspection, the tracks were rusted solid, but the engine was sound. The following year one of the men who made it oiled it up, turned the engine and after eighteen years idle it started. It was taken up the Stoney Stanton opposite Navigation Bridge until scrapped for the war effort.

A colourised busy Broadgate in 1939, taken from the NatWest steps – hence the cameraman is slightly higher than the passers-by. Owens is straight ahead and the buildings on the right would now be in Cathedral Lanes.

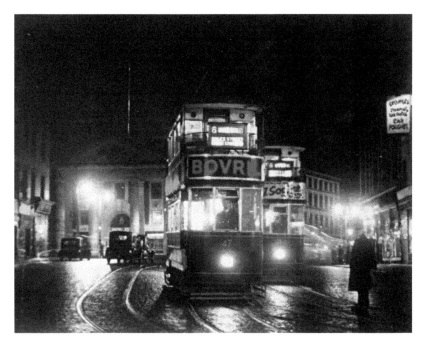

A night shot in Broadgate around 1939, taken by the late James Armer who had a photography shop on the Stoney Stanton Road. James told me that he used a plate camera on a tripod for this and the tram inspector (right) stopped the vehicles so he could take the shot.

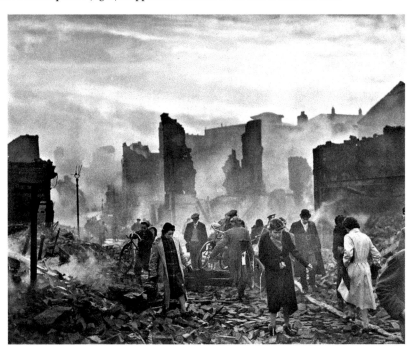

A colourised image of Little, or Much Park, Street on the morning of 15 November 1940 after eleven hours of constant bombing. Over the war period 1,252 people were killed. Surprisingly, Coventry still has no specific memorial dedicated to them in the city centre.

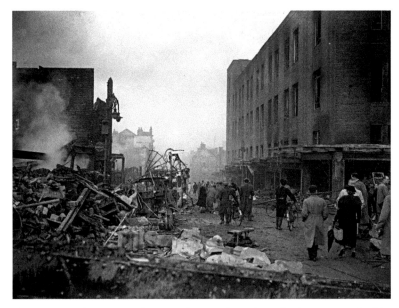

Looking down Cross Cheaping on the same day. On the right is the Owen Owen building, which was hit by a bomb in an earlier raid. It was to be repaired but was gutted by incendiaries in the November raid, which left the wrecked street and a burned-out bus, destined for Coundon. Out of 181 buses only seventy-three remained.

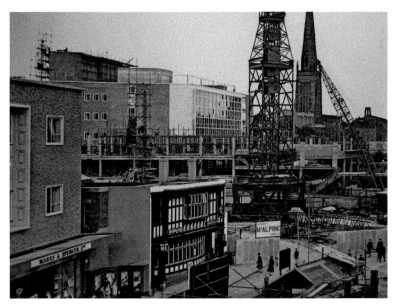

The precinct being built around the White Lion Hotel in what remained of Smithford Street in 1954. The ancient pub was closed in January 1955 and demolition took place soon after. After the November raid, when it stood among smoking ruins, the landlord was still dispensing refreshments and sausage and mash to the hungry. Fresh water was practically non-existent in the city centre, but a glassful of ale could be had, drawn from a barrel marked 'XXX' from Burton-on-Trent. The entrance mosaic was found during remodelling of the Upper Precinct and is now incorporated into a flower bed.

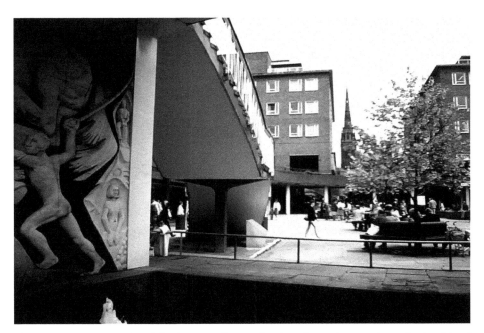

The Upper Precinct in 1965. This has not all gone but has changed many times. At the side of the water feature is Walter Ritchie's *Man's Struggle*, now on the Herbert. The steps have gone, as have the original cherry trees that were planted when it was first built. A recent improvement was the removal of the escalator, jeweller's and ramp, which has brought it more back to how we see it here.

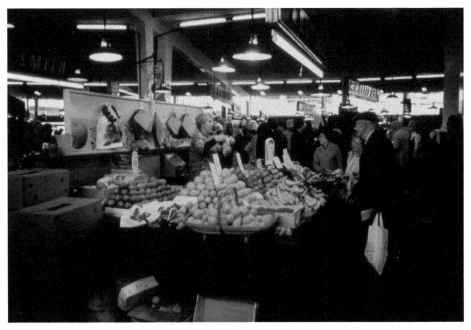

Coventry Market in 1965 when it was full of old chaps in flat caps and thick overcoats and women with permed hair, headscarves and colourful wool coats, and stalls with apples for 8*d* a pound.

The fish market in Coventry Market, which has now gone, the main stall on the right being W. E. Plastow. The counters were marble, which, along with ice, kept the fish and sea food cold. At the top of the iron columns were dancing sailors, Neptune and mermaids. They were created by artist James Brown who was influenced by ship figureheads – they still survive in the market.

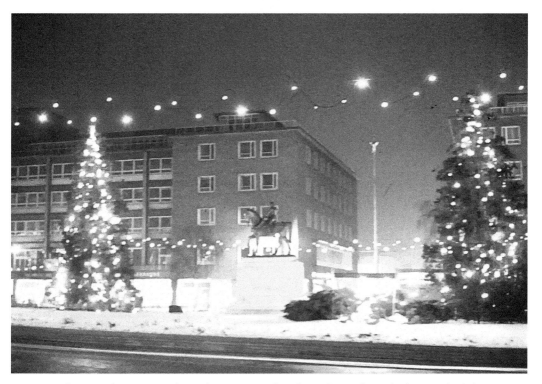

Broadgate in the snow in the early 1960s. Godiva faces the Godiva Clock instead of the precinct. Nearby in Owen Owen was Santa's grotto, with the Co-op, one of Coventry's top Christmas attractions.

Trinity Church gateway looking into Spicerstoke in the late 1920s. Through the archway can be seen Dovecote House, and to the right of the cottage next door is the top of Butcher Row and the entrance to Broadgate. The gate is long gone and now opposite stands Cathedral Lanes.

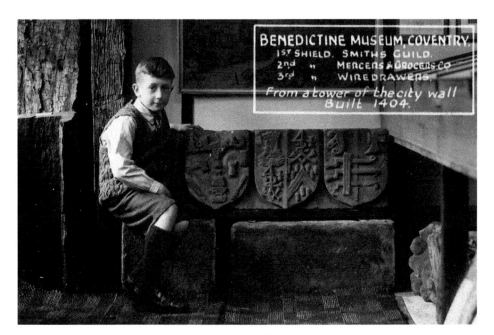

A colourised image of a young man posing in 1937 with a stone from one of the city gates. The stone shows the shields of the Smiths, Mercers and Grocers and Wire drawers rescued by J. B. Shelton and exhibited in his long-gone Benedictine Museum. This single stone was found during excavations in Priory Street along the city wall. Shelton said that a labourer was just about to smash it up with a sledge hammer when he stopped him.

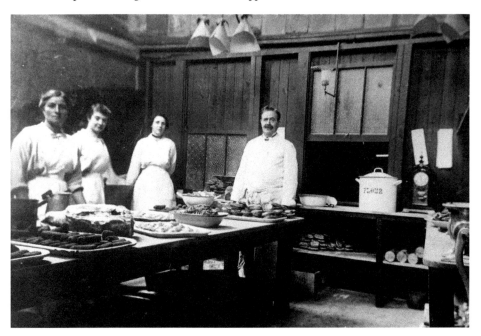

The kitchen of St Mary's Hall around 1910. The kitchen isn't lost, it has actually been restored; however, it will never look like this moment again. Of the people here, Ada Rodgers stands on the far left, and behind are two serving hatches by the stairs up to the hall.

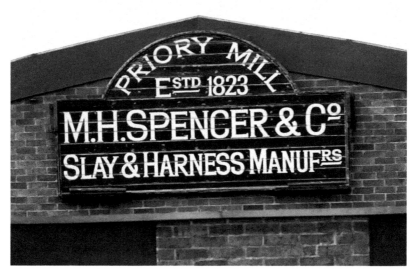

Priory Mill made reeds/slays and harness for looms. Started by Margaret Edge Banks in 1823, Thomas Spencer became her partner in 1850, taking over when the steam-powered Priory Mill was built. Thereafter the family connection was unbroken until 1959. The name M. H. Spencer was used from 1871, his wife taking over in 1878. Until 1964 they operated from a three-storey Victorian factory in Priory Street, which was built in 1861, and since its demolition the old mill's sign we see here was transferred to a new unit on Charter Avenue.

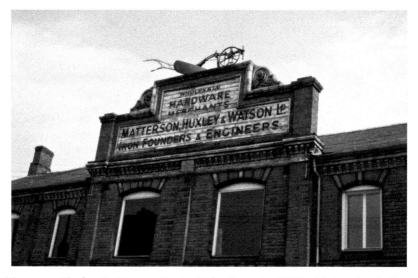

The Matterson, Huxley & Watson sign in Hales Street in 1965 with its plough. From the mid-nineteenth century the firm was noted for its iron foundry and selling agricultural machinery, tools, cattle feed and even barns and guns. In the late twentieth century it diversified, selling household goods. The plough was placed there around 1875 when the building was a warehouse for the Smithfield Cattle Market, which stood opposite, so farmers could recognise its agricultural connections. When Matterson moved in around 1894 they decided to keep it. It was taken down when the building was demolished for the extension to the transport museum in 2003/04 and moved to the company's Kingfield site.

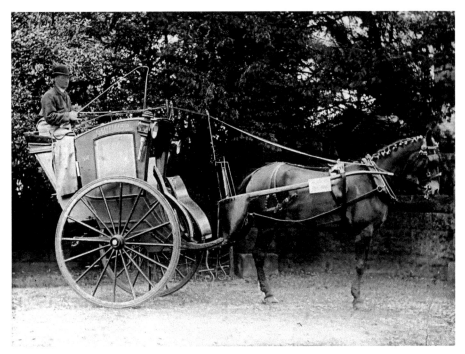

A hackney carriage (No. 54) belonging to George Littleford and attached to the King's Head stables, photographed around 1900. This was the equivalent of a taxi, and, yes, the horse does have four legs!

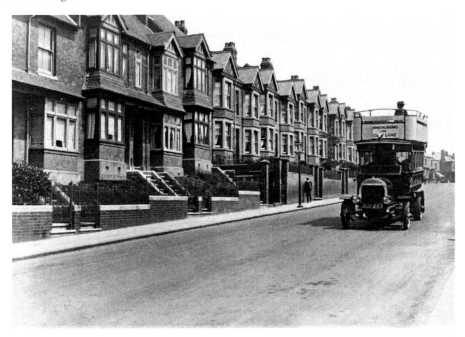

A double-decker bus on the Walsgrave Road around 1919. A fine row of houses with wrought gates and fences can be seen on the left. The old vehicles are long gone, as is the empty road, but the street remains, minus its fancy gates and is now neglected.

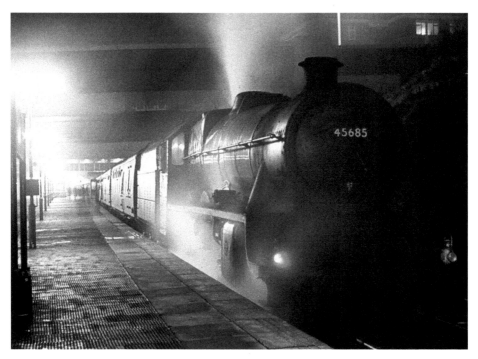

A fine old steam train in Coventry station in 1961. This is Barfleur, built in 1936 a 76-tonne Stanier-built engine made in Crewe. It was withdrawn from service in 1964. 1966 was the last year steam trains worked Coventry and in the same year the line from Coventry to London was electrified.

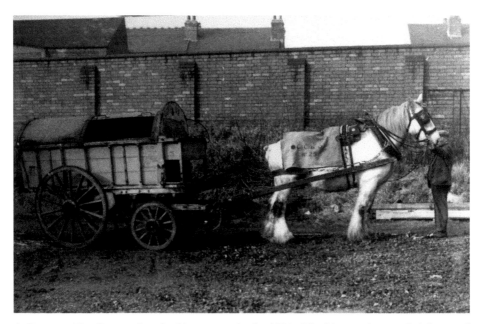

A Coventry City Corporation dustbin waggon in the 1930s. The binmen then carried the metal bins, often from the bottom of the garden all the way through the entry and back to the waggon on the road, then brought it back.

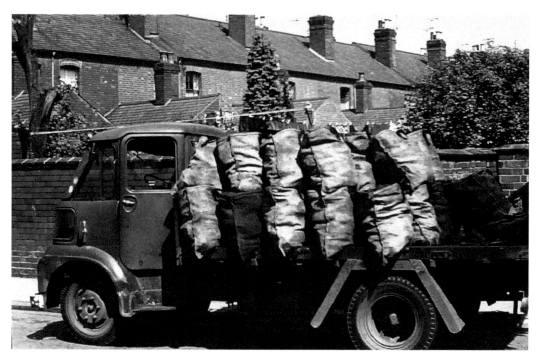

A colourised image of a coal lorry taken in the 1940s somewhere in a Coventry back street. Many will still remember the coal men heaving these heavy sacks of coal on their shoulders and emptying them into their coal houses.

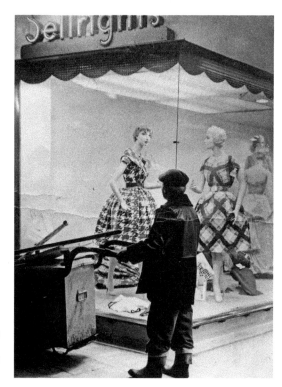

The old-style council street cleaner with cap, wellies and donkey jacket pausing to look through Sellright's window in the precinct in the 1950s.

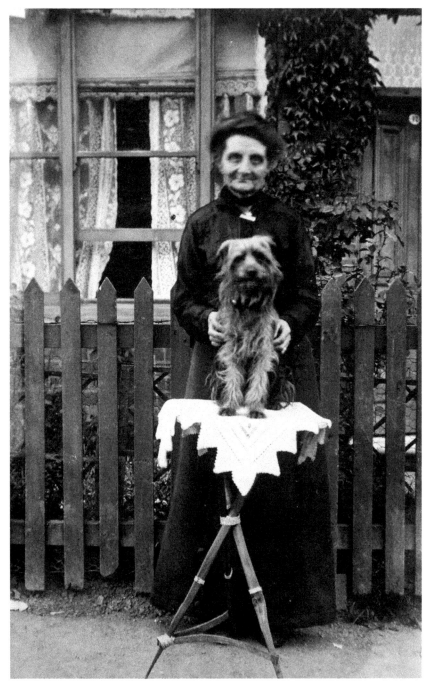

A colourised photograph of a lady posing with her dog outside her cottage, taken during the First World War outside Munition Cottages in Whitmore Park/Holbrooks. The temporary cottages were originally built for workers at the White & Poppe munition factory that once stood there. The semi-rural factory covered much of the area from Holbrook Lane to the present Beake Avenue. Munition cottages and the nearby Colony Cottages were declared slums in January 1935. In 1938, 304 cottages were demolished and 1,081 people displaced.

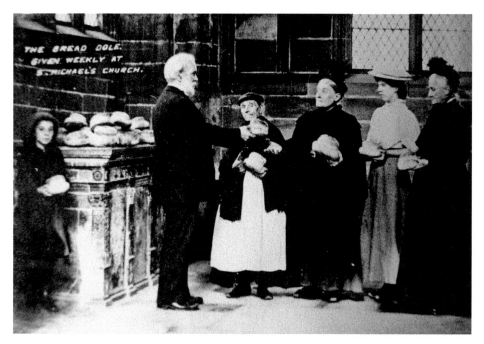

This is John Parker Owen, verger and parish clerk, giving out the weekly bread dole at St Michael's. John lived at No. 22 Bayley Lane and was verger for thirty-seven years, serving under six vicars. He officiated at hundreds of baptisms, weddings and funerals and acted as custodian, guide and guardian to the great church. He died in 1913 aged eighty-six.

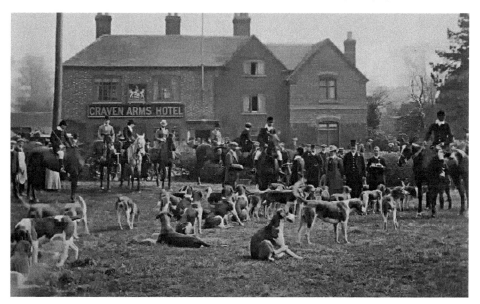

Atherstone hunt meeting outside the Craven Arms in Binley around 1923. Dan Claridge, mentioned at the beginning of this book, is seen still wearing his top hat. He advertised that it was a short stroll from the Stoke tram terminus and had illuminated lawns, its own restaurant, a picture house and bowling green. A number of different hunts met in front of the inn and Dan supplied the stirrup cups. Many of those hunts have now gone, as has the original inn.

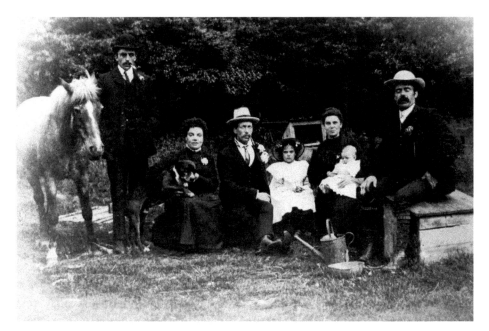

A colourised image of the Remmers of Walsgrave on Sowe in 1920 when it was still a village. The family kept the original Red Lion on the Ansty Road. In the centre are the landlord John (Bob) Robert Remmer and his daughter Iris. The original old pub stood nearer the road; it had stables and orchards on two sides where the village wake was held.

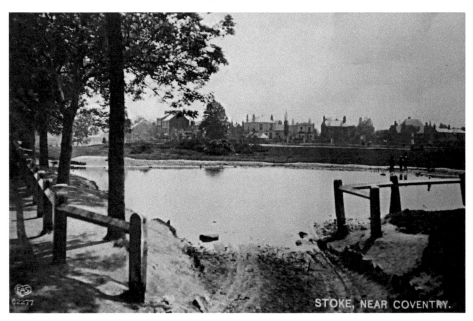

Stoke Pool, seen here colourised, in 1912 by the Binley Road at Stoke Green. The pool was used by waggons to tighten their wheels and water their horses. Note the cart tracks leading into it. The buildings in the background are by the Gentlemen's Green. The pool was filled in years ago and a paddling pool and playground built. The playground remains today, behind the Victorian Joseph Levi clock.

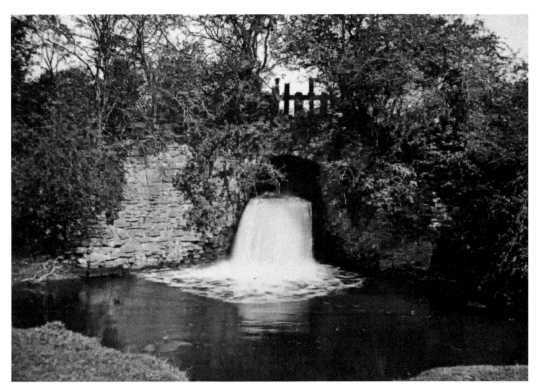

A colourised image of Foleshill waterfall above Foleshill Mill around 1905. This was part of the water system and sluicing to control the feed the water to the watermill. A short distance from the watermill, which was still in use in the 1950s, was a windmill giving the road here its name – Windmill Road.

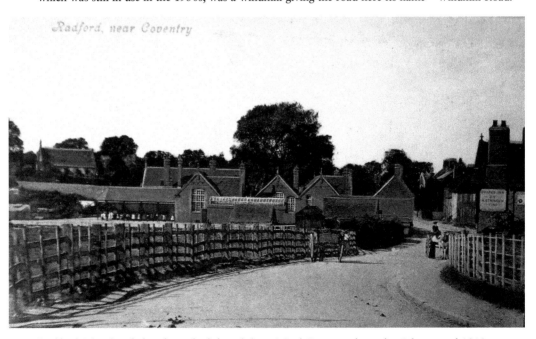

Radford School and church on the left and the original Grapes pub on the right around 1910.

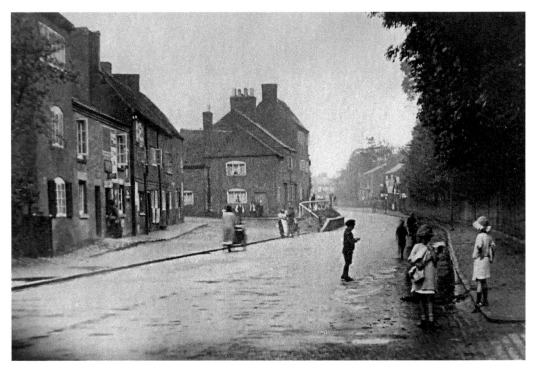

A rural Radford village in 1912 before it became a suburb. Nothing survives.

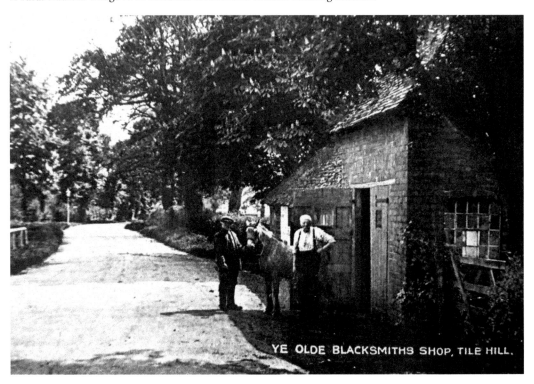

YE OLDE BLACKSMITHS SHOP, TILE HILL.

Coventry's last smithy in Duggin's Lane, Tile Hill, in 1940 with its smith, George Duggins, outside.

A colourised Stivichall Common around 1900. This old lane is in fact Coat of Arms Bridge Road. It has sadly lost its character today, by being modernised with straight tarmacked road, speed humps and pavements and general tidying up. It's still a bit rural, but no longer rustic.

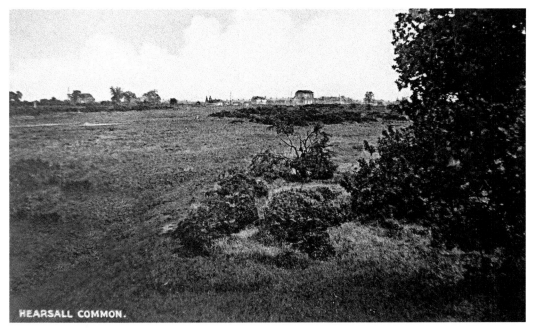

A colourised image of a rural Hearsall Common around 1900. This area is now mainly tarmac and flat grass heading going towards Earlsdon and the city centre. It shows the common as it was: a large part of it was heathland with gorse, bushes, rocks and sandpits, home to snakes and lizards and rare flowers.

A colourised photograph of Wilfred in his Sunday best on Hearsall Common, 16 July 1911. The common was a great attraction to Coventrians who studied the flora and fauna here and often walked on to Berkswell – all part of a typical Sunday afternoon after church. This is Wilfred Newsome Bunney (then aged five) of Albany Road, son of the artist Sidney Bunney. The museum has 500 of his father's Coventry watercolours. Wilfred became a clerk and married Marjorie Monk in 1928. He lived until he was ninety-five.